PHOTOGRAPHING CHILDREN

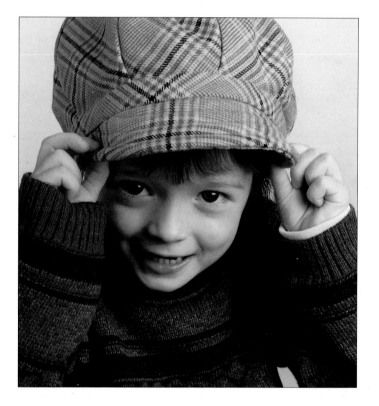

PRO PHOTO

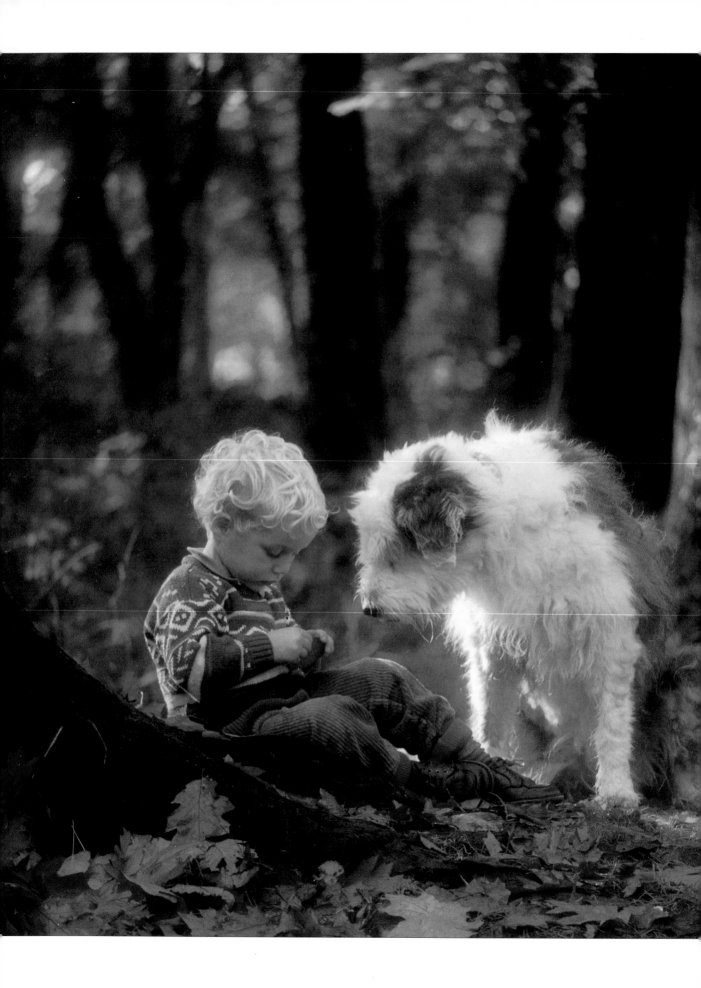

ROTOVISION
PRO-PHOTO SERIES

PHOTOGRAPHING CHILDREN

JONATHAN HILTON

A RotoVision Book

Published and distributed by RotoVision SA
Rue Du Bugnon 7
1299 Crans-Pres-Celigny
Switzerland

RotoVision SA, Sales & Production Office
Sheridan House, 112/116A Western Road
HOVE BN3 1DD
Tel: +44-1273-7272-68
Fax: +44-1273-7272-69

Distributed to the trade in the United States:
Watson-Guptill Publications
1515 Broadway
New York, NY 10036

ISBN 2-88046-276-2

This book was designed, edited and produced by
Hilton & Kay
63 Greenham Road
London N10 1LN

Design by Phil Kay
Illustrations by Julian Bingley
Picture research by Anne-Marie Ehrlich

DTP in Great Britain by
Hilton & Kay
Printed in Singapore by Teck Wah Paper Products Ltd.
Production and separation in Singapore by ProVision Pte. Ltd.
Tel: +65-334-7720
Fax: +65-334-7721

Photographic credits
Front cover: Nigel Harper
Page 1: Anne Kumps
Pages 2–3: Ronald and Tracy Turner
Page 160: Nigel Harper
Back cover: Llewellyn Robins

CONTENTS

1 CHILDREN'S PORTRAITS

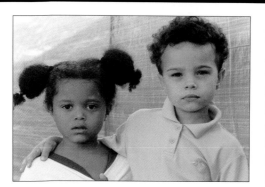

MOOD AND ATMOSPHERE 2

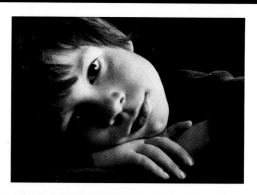

3 CANDID APPROACH

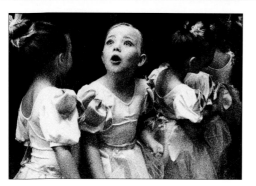

CONTENTS

4 INTERESTS AND ACTIVITIES

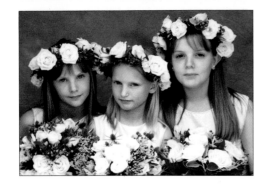

PORTFOLIOS 5

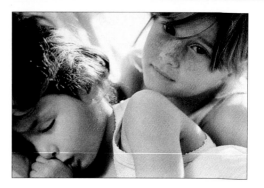

INTRODUCTION

Children make endlessly fascinating subjects for photographers – both amateurs and professionals alike. There is hardly a household in the land where there is not a camera of some description to be found, and in those households where children are also present they will almost certainly become the subject of literally hundreds, if not thousands, of photographs as the years pass by.

What, then, is the universal appeal of photographing children? For parents, the answer is obvious: having a complete photographic record of their children as they grow from baby- and toddlerhood, through adolescence and teens, and on to adulthood is the perfect way of keeping their memories forever fresh. And because children develop so very rapidly in their first few years – both physically and emotionally – and their moods are often so unpredictable and volatile – tears one moment and laughter the next – there is always another achievement or revealing facet of their character to record on film.

If you are a professional photographer, building up your expertise and reputation as a photographer of children can become an important element of your business strategy. Schools, nurseries, and playgroups often commission annual photographs of their students, either in class groups and/or individual portraits, for sale to parents. The amount of income from just a single commission of this type can be significant, and there is every likelihood of some additional

PHOTOGRAPHER:
Ronald & Tracy Turner

CAMERA:
35mm

LENS:
135mm

FILM SPEED:
ISO 100

EXPOSURE:
¹⁄₁₂₅ second at f4

LIGHTING:
Daylight only

▼ *Good, revealing photographs of children don't have to show facial features at all. In this double portrait, body language alone communicates the bond of affection between this brother and sister as they sit together watching the sea creeping up the beach.*

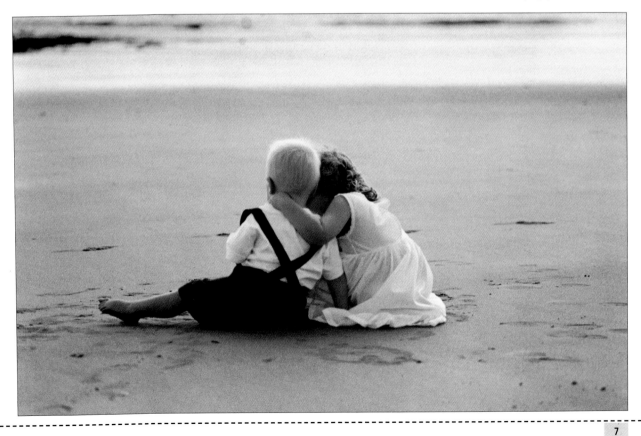

PHOTOGRAPHER:
Ronald & Tracy Turner
CAMERA:
35mm
LENS:
90mm
FILM SPEED:
ISO 100
EXPOSURE:
⅟₆₀ second at f5.6
LIGHTING:
Daylight and reflector

◄ *Formal portraits can be taken outdoors just as well as in the more traditional studio environment. The warm afternoon light of early fall in this portrait has been supplemented with bounced light from a gold-coloured reflector, which was held just out of sight beneath the subject's face.*

commissions for such things as birthday parties, christenings, communions, bar-mitzvahs, and other non-school events stemming from it.

Additional sources of income could also come from covering school drama activities, band and orchestra perfor-mances, junior athletics, and sports day events. And don't overlook the possibility of interesting the local press in your photographs. Most local newspapers operate with the minimum of staff and so they are reliant on freelancers to fill the gaps in local news coverage left by their staff photographers.

Studio-based approach

Having a studio base is an obvious advantage in attracting commissions, but for many photographers just starting out

in business the costs may be prohibitive. If so, then consider working as part of a loose cooperative, sharing costs with two or three other photographers in a similar situation. With your pooled resources, even if meagre, you should have available a wider range of equipment and acces-sories than you would be able to afford as individuals. As well, if you are working only part-time as a professional photogra-pher, as many are forced to do in their early careers, there is a better chance of somebody being available to cover any commissions that come into the studio.

Non-studio approach

Working outside of a studio environment does not necessarily mean shooting out-doors. Some clients, for example, may want their children photographed in their

own homes, and so you will need to have a basic location lighting kit readily available. Two lights, diffusing material or a softbox, a snoot or barndoors, and a tripod should cover most situations. Always useful are rolls of wide, heavy-duty paper. These allow you to show your subject against a plain and uncluttered background if necessary. There is always the danger of coloured papers clashing with your subjects' clothing, so safer options are black, white, and grey.

Equipment needs are always more difficult to predict when shooting out-doors, mainly due to the vagaries of the weather. Moderate telephoto lenses are probably most generally useful, and in case of overcast conditions you will need accessory flashguns and some simple reflectors to add a little sparkle.

EQUIPMENT AND ACCESSORIES

Predominantly, children's portrait photographers work from a studio base – their own, one shared with other photographers, or one that can be readily hired – or in their subjects' homes, schools, or playgroups. When not on location, the camera format most often used by portrait photographers is one of the medium format types. These cameras produce a larger negative (or positive slide image) than the next most popular format – the 35mm camera – which is ideal when working away from the studio. Generally, the larger the original film image, the better the quality of the resulting print, since it requires less enlargement. The often relatively slow pace of a portrait session also seems to favour the use of the larger format, since it tends to encourage a more considered approach to each shot. However, good-quality 35mm SLR cameras and lenses can produce superb results, and they come into their own when hand-held shooting is necessary, for 'grabbed', candid-type shots, or when the session is perhaps unpredictable and the photographer needs to respond very quickly.

MEDIUM FORMAT CAMERAS

Traditionally, the camera type most often used by portrait photographers is the medium format rollfilm camera. This format, of which there are many variations, is based on 120 (for colour or black and white) or 220 (mainly black and white) rollfilm. Colour film has a thicker emulsion than black and white, and so 220 colour film is not generally available because it cannot be physically accommodated in the camera's film chamber.

◀ The smallest of the medium format cameras, producing rectangular negatives or slides measuring 6 by 4.5cm.

◀ This is probably the best known of all the medium format cameras, producing square-shaped negatives or slides measuring 6 by 6cm.

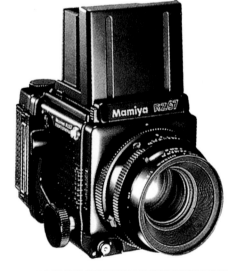

◀ This is the largest of the popular medium format cameras, producing rectangular negatives or slides measuring 6 by 7cm. (A 6 by 9cm camera format is also available.)

The three most popular sizes of medium format cameras are 6 x 4.5cm, 6 x 6cm, and 6 x 7cm models. The number of exposures per roll of film you can typically expect from these three cameras are:

Camera type	120 rollfilm	220 rollfilm
6 x 4.5cm	15	30
6 x 6cm	12	24
6 x 7cm	10	20

The advantage most photographers see in using medium format cameras is that the large negative size – in relation to the 35mm format – produces excellent-quality prints, especially when big enlargements are called for, and that this fact alone outweighs any other consider-ations. The major disadvantages with this format are that, again in relation to the 35mm format, the cameras are heavy and slightly awkward to use, they are not highly automated (although this can often be a distinct advantage), they are expensive to buy, and you get fewer exposures per roll of film.

35MM SINGLE LENS REFLEX CAMERAS (SLRs)

Over the last few years, the standard of the best-quality lenses produced for the 35mm SLR has improved to the degree that for average-sized portrait enlarge-ments – of, say, 8 x 10in (20 x 25cm) – results are superb.

The 35mm format is the best supported of all the formats, due largely to its popularity with amateur photogra-phers. There are at least six major 35mm manufacturers, each making an extensive range of camera bodies, lenses, dedicated flash units, and specialized as well as

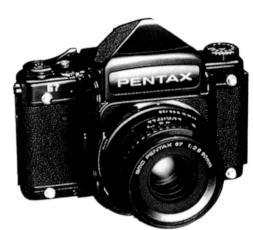

◀ This type of 6 by 7cm medium format camera looks like a scaled-up 35mm camera, and many photographers find its controls easier to use than the type shown on page 9.

more general accessories. Cameras within each range include fully manual and fully automatic models. Lenses and accessories made by independent companies are also available. Compared with medium format cameras, 35mm SLRs are lightweight, easy to use, generally feature a high degree of automation, and are extremely flexible working tools. For big enlarge-ments, however, medium format cameras have an edge in terms of picture quality.

All 35mm SLRs use the same size of film cassette, of either 24 or 36 shots, in colour or black and white, positive or negative. Again, because of this format's popularity, the range of films available is more extensive than for any other camera.

LENSES

When it comes to buying lenses you should not compromise on quality. No matter how good the camera body, a poor-quality lens will take a poor-quality picture, and this will become all too apparent when enlargements are made. Always buy the very best you can afford.

One factor that adds to the cost of a lens is the widest maximum aperture it offers. Every time you change the aper-ture to the next smallest number – from f5.6 to f4, for example – you double the amount of light passing through the lens, which means you can shoot in progres-sively lower light levels without having to resort to flash. At very wide apertures,

◀ This top-quality, professional 35mm camera, here fitted with a motor drive, features a rugged die-cast body; a choice of three different metering systems; inter-changeable viewing screens and finders; exposure lock and expo-sure compensation; and a choice of aperture- or shutter-priority, fully automatic, or fully manual exposure modes.

however, the lens needs a high degree of optical precision to produce images with minimal distortion, especially towards the edges of the frame. Thus, lenses offering an aperture of f1.4 cost much more than lenses with a maximum aperture of f2.8.

At a 'typical' portrait session, you may need lenses ranging from wide-angle (for showing the setting as well as the subject, or for large-group portraits) through to moderate telephoto (to allow you to concentrate on the face or head and shoulders of your subject). For 35mm cameras, the most useful lenses are a 28 or 35mm wide-angle, a 50mm standard, and about a 90 to 135mm telephoto.

As an alternative, you could consider using a combination of different zoom lenses. For example, you could have a 28–70mm zoom and another covering the range 70–210mm. In this way you have, in just two lenses, the extremes you are likely to use, plus all the intermediate settings you could possibly need to 'fine-tune' subject framing and composition.

There is less choice of focal lengths for medium format cameras. They are also larger, heavier, and more expensive to buy, but the same lens categories apply – in other words, wide-angle, standard, and moderate telephoto. There is also a limited range of medium format zoom lenses from which to choose.

▶ 'Hammer-head' style accessory flash units are capable of producing high light levels and are often used with heavy-duty battery packs. Always choose a model with a tilt-and-swivel head facility for a variety of lighting effects.

ACCESSORY FLASH

The most convenient artificial light source for a portrait photographer working on location is undoubtedly an accessory flashgun. Different flash units produce a wide range of light outputs, so make sure that you have with you the one that is most suitable for the type of area you wish to illuminate.

Tilt-and-swivel flash heads give you the option of bouncing light off any convenient wall or ceiling. In this way, your subject will be illuminated by reflected light, which produces a kinder, more flattering effect. You need to bear in mind, however, that some of the power of the flash will be dissipated as a result.

The spread of light leaving the flash head is not the same for all flash units. Most are suitable for the angle of view of moderate wide-angle, normal, and moderate telephoto lenses. However, if you are using a lens with a more extreme focal length, you may find the light coverage inadequate. Some flash units can be adjusted to suit the angle of view of a range of focal lengths, or adaptors can be fitted to alter the spread of light.

LONG-LIFE LIGHTING

One of the problems of using accessory flash is the number of times the flash will fire before the batteries are exhausted. There is also the problem of recycling speed – the time it takes for the batteries to build up sufficient power in order to fire once more. With ordinary batteries, after as few as 30 firings recycling time may be so long that you need to change batteries (the fresher the batteries, the faster the recycling time). This is not only expensive, it is also time consuming. The solution to these problems is to use a battery pack. With some types of pack, when fully charged you can expect as many as 4,500 firings and a flash recycling time as low as ¼ second – which is fast enough to use with a camera and motor drive. These figures do, of course, assume optimum conditions, such as photographing a close subject, with plenty of reflective surfaces nearby to return the light, and with the flashgun set to automatic.

Flash bracket

When you are using camera-mounted flash by preference, or when circumstances dictate, the type of flash bracket illustrated here could be a boon. By lifting the flash head well above the level of the lens, the possibility of 'red-eye' is completely eliminated. This model is designed to accommodate 35mm SLRs as well as 6 x 4.5cm format cameras. It allows both camera types to be used either horizontally or vertically while ensuring that the flash remains centred directly above the lens. A front-mounted shutter release is also included for extra convenience. Different brackets are available for square-format cameras and for those with rotating backs.

▼ *This type of flash bracket neatly overcomes the major problem associated with camera-mounted accessory flash – red-eye – by lifting the lighting head well above the level of the lens.*

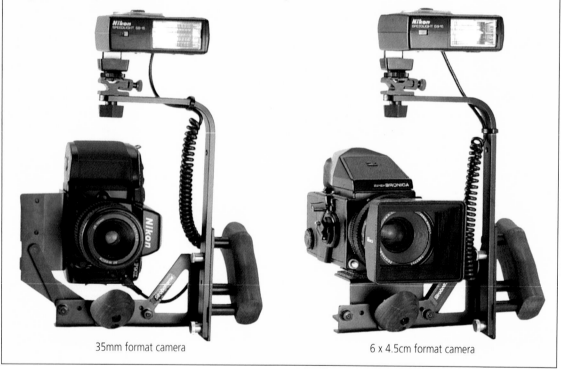

35mm format camera 6 x 4.5cm format camera

STUDIO FLASH

For the studio-based children's photographer, the most widely used light source is studio flash. Working either directly from the mains or via a high-voltage power pack, recycling time is virtually instantaneous and there is no upper limit on the number of flashes.

A range of different lighting heads, filters, and attachments can be used to create virtually any lighting style or effect, and the colour temperature of the flash output matches that of daylight, so the two can be mixed in the same shot without any colour cast problems.

When more than one lighting head is in use, as long as one of the lights is linked to the camera's shutter, the other lighting heads can be fired using slave units. Another advantage of flash is that it produces virtually no heat, which can be a significant problem when using studio tungsten lighting. To overcome the problem of predicting precisely where subject shadows and highlights will occur (which cannot normally be seen because the burst of light from the flash is so brief), each flash head should be fitted with a 'modelling light'. The output from these lights is low and so will not affect exposure, but it is sufficient for you to see the overall effect with a good degree of accuracy.

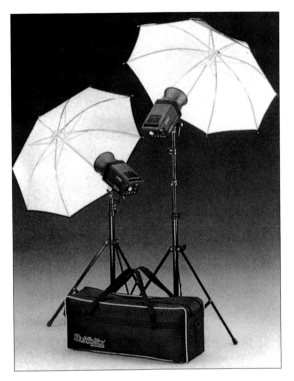

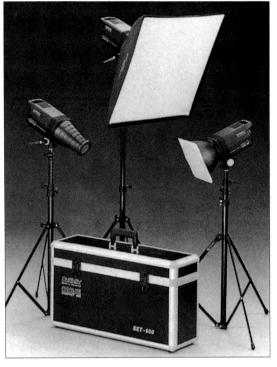

▲ Above left: *These modern studio flash units have been designed with location work in mind. This set-up, comprising two lighting heads, umbrellas, and lighting stands, packs away into the flexible carrying bag illustrated.*

▲ Above right: *For a wider range of lighting effects, this set-up has three lighting heads, with add-on softbox, snoot, and scrim, and three lighting stands. It all packs away into the case illustrated, which would easily fit into the trunk or the back seat of a car.*

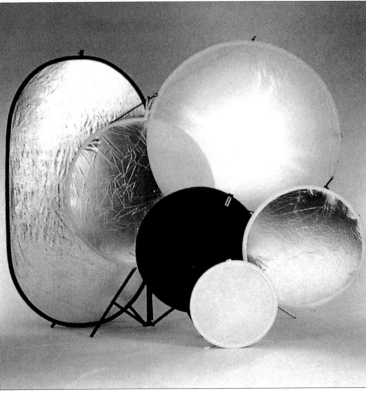

▶ *Reflectors can be made out of pieces of cardboard – white for a neutral effect or coloured for more unusual results. But professional reflectors, made from materials with different reflective qualities, allow you a greater degree of control, either in the studio or when you are out on location.*

1

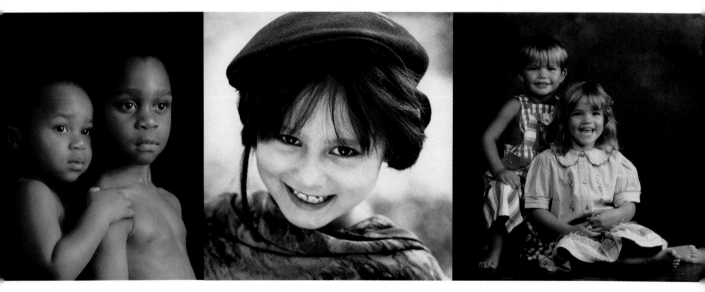

CHILDREN'S PORTRAITS

BASIC STUDIO REQUIREMENTS

Many people may be put off by the term 'studio' photography, thinking that a purpose-built space full of expensive equipment is essential. In fact, if you have an interest in children's portraiture, or any other aspect of children photography, you really require only the most basic of facilities. For indoor work, you need to have a spare room, or an area in any room of your home that you can clear of extraneous clutter – either permanently or just whenever you want to conduct a photographic session. A selection of background papers will also be useful. These not only allow you to vary the colour and/or texture of the backdrop to your pictures, they also help to disguise such domestic details as the edges of window and door frames, power points, less-than-perfect paintwork, and so on that could become distracting features if they were to appear in your finished prints.

In the overwhelming majority of cases, a 35mm SLR camera will be more than adequate, assuming that you don't skimp on the quality of your lenses. The only time a medium format camera (6 x 4.5cm or larger) is really essential is if you intend to make exceptionally large prints.

The type of lenses you may need depends on the size of your working area and how far away from your subjects you will be. Assuming you are shooting in an 'average' size of room, then probably the most useful focal length (for the 35mm format) is 90mm. This lens is often referred to as a 'portrait lens' because it allows you to stand comfortably back from your subject and yet still fill the frame with a head-and-shoulders composition. Lenses much longer than this (150mm and longer) may start to produce a slightly squashed perspective, while those that are much shorter (50mm or less) mean that you have to approach very close to the subject if you want a good-sized close-up type of framing.

If the room you are using is correctly orientated, you may be able to use natural light for the majority of your work. Ideally, you want a room with large windows that receive a lot of indirect sunlight. If direct sunlight streams into the room, contrast may become too extreme, with highlights being very bright and shadows very

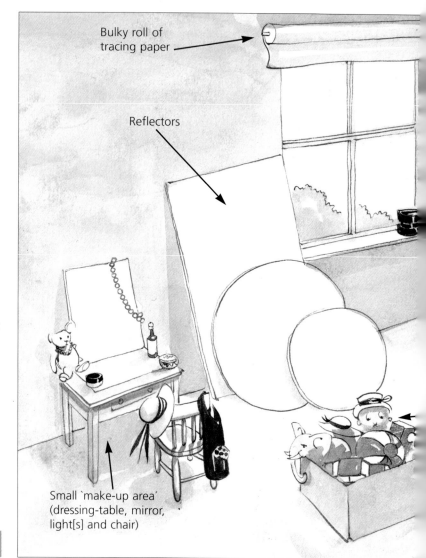

Bulky roll of tracing paper

Reflectors

Small 'make-up area' (dressing-table, mirror, light[s] and chair)

dense. Even if this is the case, you can often fill in the shadow areas a little using reflectors. However, the disadvantage of relying on natural light is that the weather is not always reliable. You don't want to find yourself in the situation where you cannot work on overcast or rainy days, for example. The most flexible form of artificial illumination is definitely flash. At first you may be able to make do with an accessory flashgun or two, especially in a small area, or you may want to buy a basic studio lighting outfit consisting of two portable flash heads, lighting stands, a softbox (or flash umbrella), and a snoot. The major advantages of using flash (as opposed to continuous-light tungsten heads) is that the flash produces virtually no heat, the units can be fired using slave triggers (so you don't have power leads everywhere), and the light output can be mixed with daylight without colour casts.

The most useful studio accessory is a good-quality tripod. Even if camera shake is not a concern when handholding the camera, fixing the camera to a tripod leaves both of your hands free and it also gives you a fixed reference point around which you can fine tune the positions of your lights and your subjects' poses.

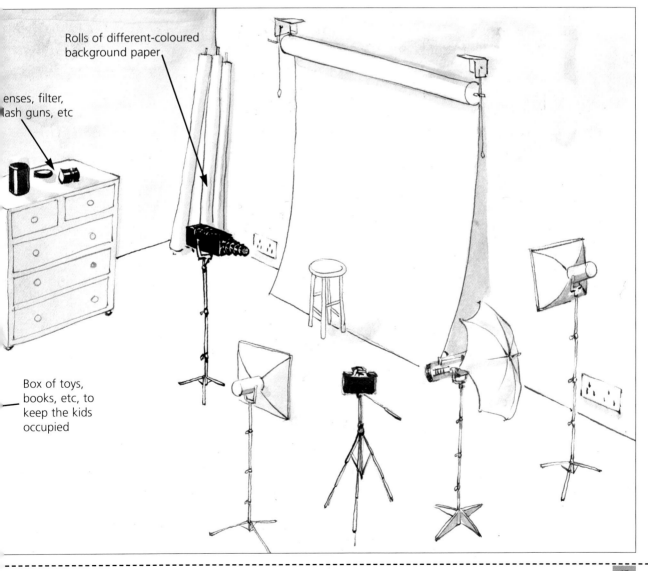

Rolls of different-coloured background paper

enses, filter, lash guns, etc

Box of toys, books, etc, to keep the kids occupied

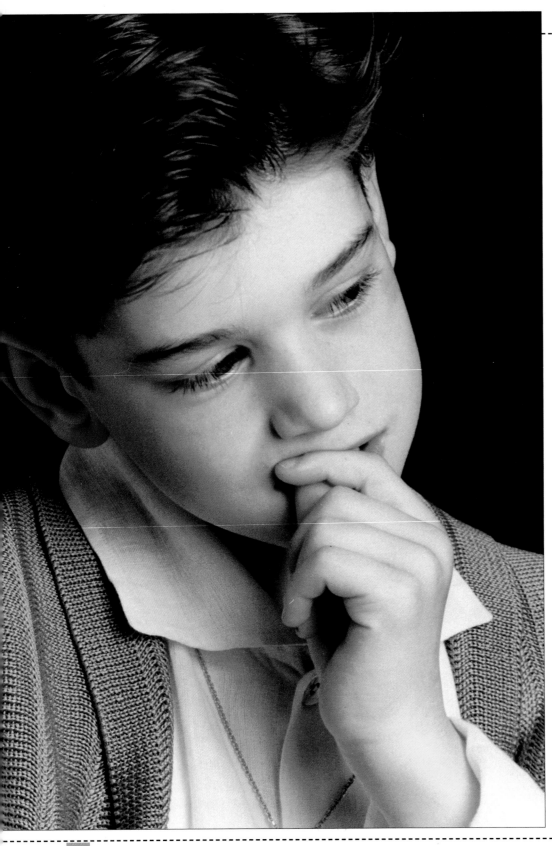

◀ *If the windows of the room you are shooting in receive bright but indirect light, then you may not need any form of artificial illumination. For this portrait, the photographer simply orientated the subject carefully in relation to a large picture window, checking through the camera's viewfinder that lighting contrast on the face was not extreme. The dark background is not the result of using any background paper – the exposure difference between the subject and the rest of the room was such that everything except the immediate foreground was massively underexposed.*

PHOTOGRAPHER:
Anne Kumps

CAMERA:
35mm

LENS:
**70–210mm zoom
(set at 90mm)**

FILM SPEED:
ISO 100

EXPOSURE:
¹⁄₂₅ second at f4

LIGHTING:
Daylight only

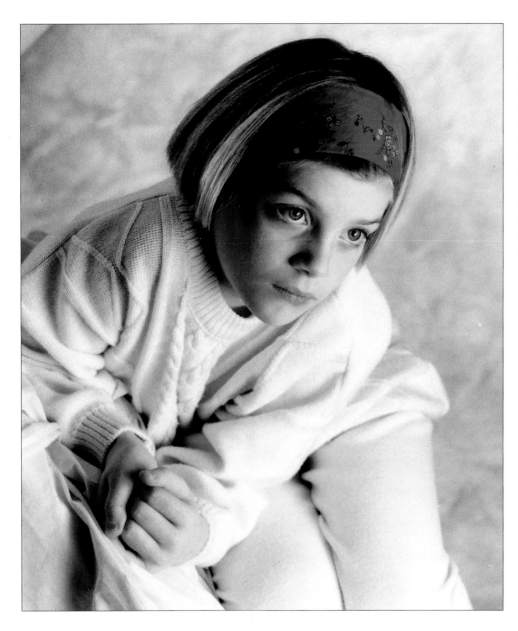

◀ *In a basic home studio you can achieve perfectly good photographs using the minimum of equipment. For this portrait the backdrop consists of a large square of crumpled material attached to a portable stand and an unbleached bed sheet covers the settee on which the subject is posing. For this image, a flash head was used with another light pointing directly at the backdrop and reflecting back on to the subject.*

PHOTOGRAPHER:
Anne Kumps

CAMERA:
35mm

LENS:
**70–210mm zoom
(set at 110mm)**

FILM SPEED:
ISO 100

EXPOSURE:
⅟₆₀ second at f8

LIGHTING:
Studio flash x 2

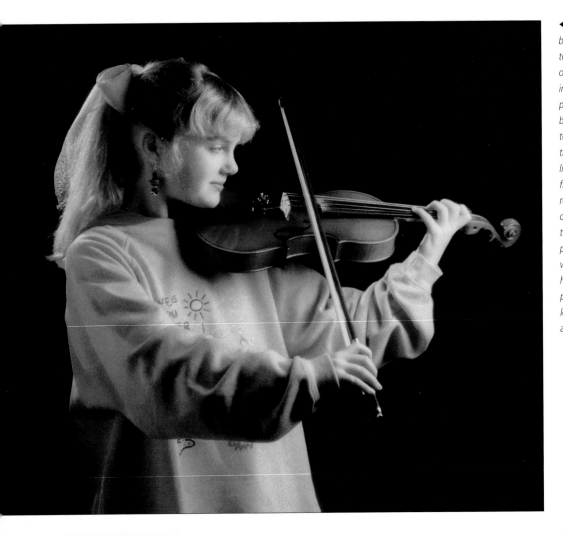

◀▶ *A range of different background papers allows you to transform the atmosphere of your pictures. In the first image here (left), the subject is posing in front of a black background. Even so, she had to be placed well forward of the paper to ensure that no light from a frontal bounced flash and a direct backlight reached the paper and produced a lighter grey tone. In the next image (right), the paper has been changed to white and the photographer has also smeared a little petroleum jelly on a clear-glass lens filter to diffuse the light at the bottom of the frame.*

PHOTOGRAPHER:
Anne Kumps

CAMERA:
35mm

LENS:
**28–70mm zoom
(set at 65mm)**

FILM SPEED:
ISO 100

EXPOSURE:
⅙₀ second at f5.6

LIGHTING:
**Studio flash x 2 (1 fitted
with flash umbrella)**

PHOTOGRAPHER:
Anne Kumps

CAMERA:
35mm

LENS:
**70–210mm zoom
(set at 110mm)**

FILM SPEED:
ISO 100

EXPOSURE:
⅙₀ second at f4

LIGHTING:
**Studio flash x 1
(fitted with softbox)**

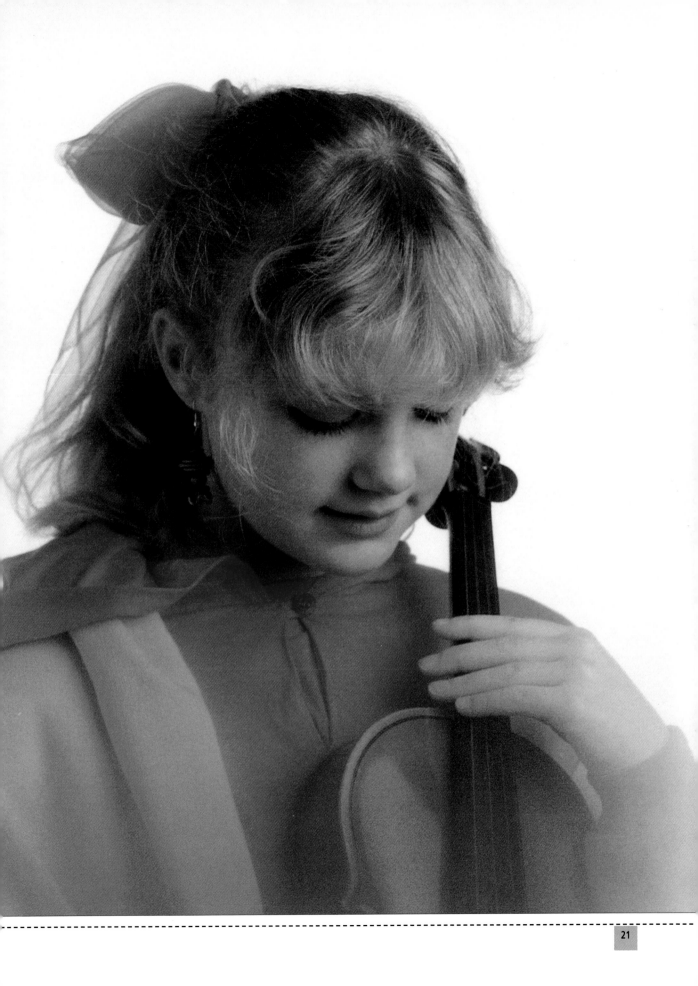

CONDUCTING A STUDIO SESSION

Your studio approach to photographing children of the ages shown on these pages must be very different to that needed for photographing babies and toddlers (*see pp. 38–45*).

During a productive and well-organized studio session your aim should be to build a rapport with, and enlist the active support of, your young subjects. If you make their hour or two in front of the lights a fun time, your chances of drawing out from them a good variety of poses and facial expressions are going to be that much greater.

After their initial shyness, children will be naturally curious about the cameras, lights, and all the paraphernalia associated with a photographic studio. Make an effort to explain, in simple and appropriate language, what all the equipment does, where you want them to stand (and why), and what they should be doing.

Bear in mind that children are easily distracted. If, for example, you take too long fine-tuning lighting position, changing film, and taking light readings, you stand a chance of losing their attention and cooperation.

Hints and tips

● Have a selection of books and toys to hand to keep your subjects entertained while they are in the studio. These could then become invaluable as props during the actual photographic session.

● If you want to take movement and action shots, playing their favourite music may help. Arrange for them to bring their own tapes with them when they come to the studio.

● If you have more than one child in the studio at the same time, you may be able to shoot the way they interact with one another.

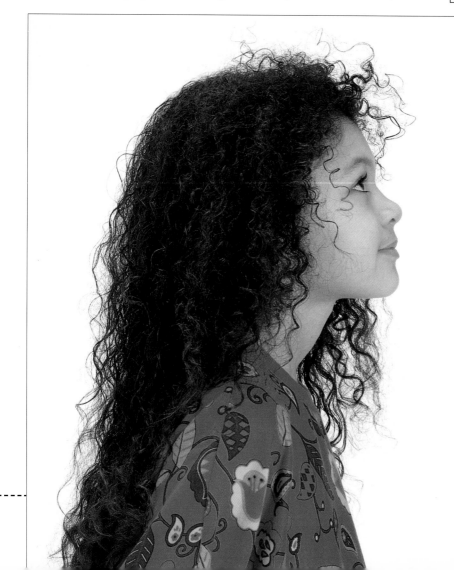

◀ *A simple, white-painted background is a good choice when your subject is wearing a bright, multicoloured top. The eyes of the subject are particularly important in a posed portrait such as this, so make sure that your subjects knows exactly where to look.*

PHOTOGRAPHER:
Tim Ridley

CAMERA:
6 x 6cm

LENS:
150mm

FILM SPEED:
ISO 100

EXPOSURE:
1/125 second at f8

LIGHTING:
**Studio flash x 2
(one fitted with softbox)**

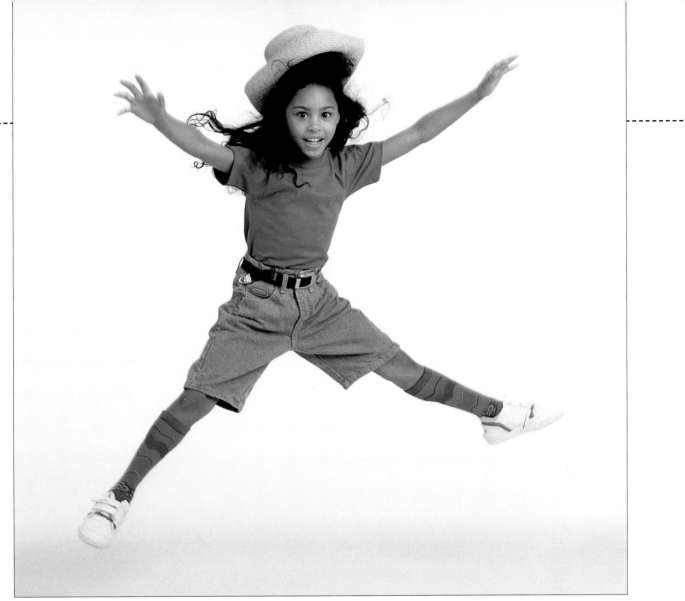

▲ This action pose is full of fun and vitality. The rapid, almost instantaneous, recycling times of studio flash is vital, allowing you to shoot at will as the subject goes through her paces. Take more shots than you think you need and select the ones afterwards where pose, facial expression, hand and feet positions, and so on work well together.

▶ Studio flash units placed either side of the camera position, and set at about 45° to the subject, were used for this shot. Both flash units were fitted with softboxes to spread and diffuse the light.

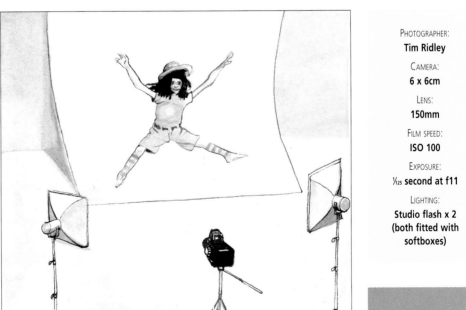

PHOTOGRAPHER:
Tim Ridley

CAMERA:
6 x 6cm

LENS:
150mm

FILM SPEED:
ISO 100

EXPOSURE:
1/125 second at f11

LIGHTING:
Studio flash x 2 (both fitted with softboxes)

AN EYE FOR DETAIL

Except when taking grabbed candid shots, you will have some time to consider subject composition – even if it is only a few seconds.

It is all too easy to concentrate so hard on the principal subject – the child's pose, facial expression, and so on – that you fail to evaluate the pictorial effects of surrounding shapes, tones, or colours and the impact these could have. A young, brightly clothed child could, for example, easily become 'lost' in an over-busy background. The bright colours and active patterns and designs used on many products designed for children can simply become distracting and competing elements when seen as part of a print or slide.

Hints and tips

● If you have time, before taking any photograph look carefully at all of the viewfinder image, noting what effect background and foreground colours and patterns will have on the subject in the final print. Don't forget to look at the frame corners to make sure there are no distracting elements there.

● If you are shooting on black and white film, you will have to translate the colour scene of the viewfinder into a monochrome image. Be aware that distinctly different colours can be recorded as very similar tones, or that very similar colours as distinctly different tones. If the subject and background tones are too similar, the impact of a photograph could be lessened.

● Often, a simple shift in camera position is enough to crop out an unwanted background or foreground element. Equally, shifting the camera position may bring into view something in the setting that makes a positive contribution to composition. Moving camera position is often a better option than repositioning the subject, especially if you don't want to intrude on your subject's mood.

● If, for some reason, both camera and subject positions are fixed, try using different lens apertures to modify depth of field, and so render foreground and background elements either more or less sharp. Don't use an aperture, however, that forces you to select an inappropriate shutter speed.

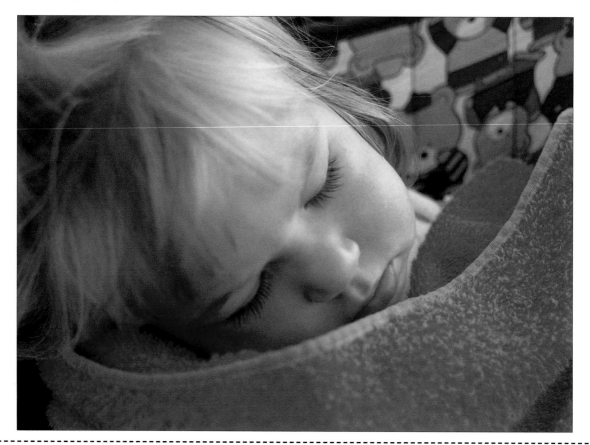

PHOTOGRAPHER:
Tim Ridley

CAMERA:
35mm

LENS:
85mm

FILM SPEED:
ISO 64

EXPOSURE:
⅟₆₀ second at f5.6

LIGHTING:
Daylight only

◀ ▶ *Looking at these two images of the same sleepy subject, you can see the dramatic difference achieved by a small change of camera position and switching from a horizontal to a vertical picture format. In the smaller version (left), the child's face is seen against the bright teddy bear lining of her push chair. The effect of this, initially, is to draw the viewer's eye past the subject. For the larger version (right), the photographer moved slightly to the right, turned the camera around, and cropped in tightly on the side of the child's head. This effectively removed the distracting lining and introduced an out-of-focus and neutral frame for the face.*

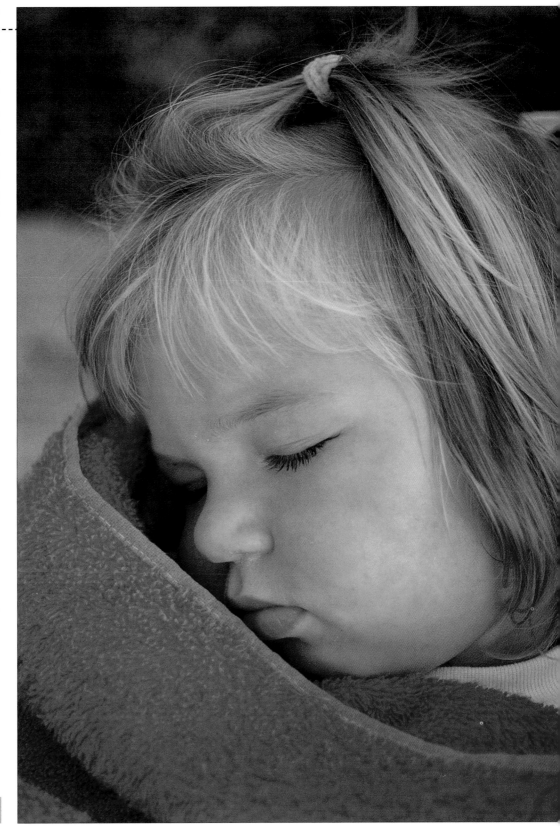

CHOOSING SIMPLE BACKGROUNDS

When photographing on location, either outdoors or in a client's home, you need to pay particular attention to the backgrounds to your shots – where you pose or, for candids, frame your subjects. Backgrounds are usually taken account of automatically in the studio, since erecting flats or deciding on the colour and style of any background paper is one of the first things you would do when creating a set.

Unless the background has a positive contribution to make to the mood or atmosphere of the shot, or unless it tells the viewer something extra about the subject, a plain and uncluttered setting is often preferable to one that potentially distracts the eye by competing for attention. When working with colour film, make sure that the colour of the background does not clash with the clothes or complexions of your subjects. Colour is obviously not a consideration when working in black and white. However, every hue translates into a different tone and, unless you take care, you may find that the tones of your subject and those of the background are either too similar or jarring in their contrast.

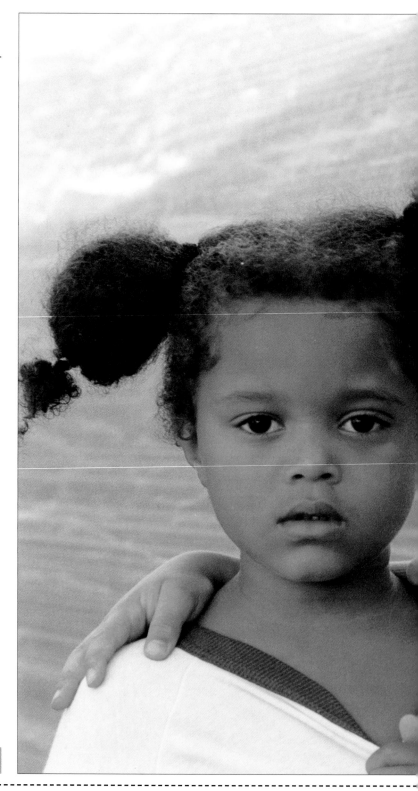

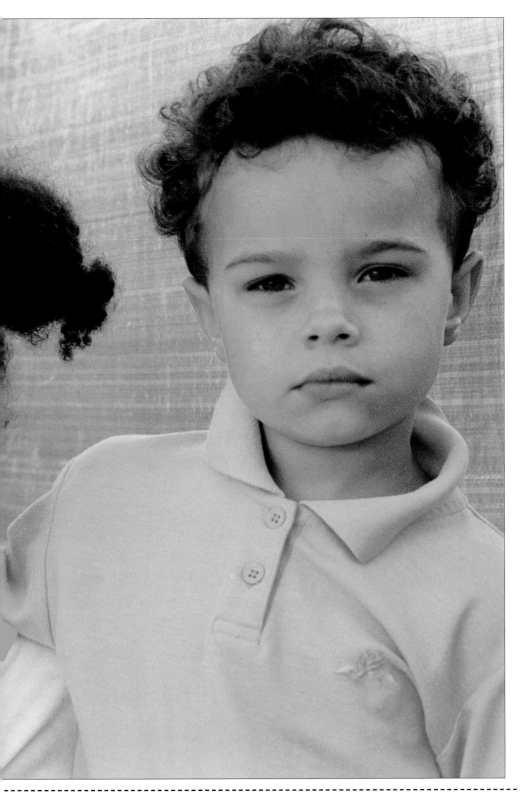

PHOTOGRAPHER:
Majken Kruse

CAMERA:
35mm

LENS:
70mm

FILM SPEED:
ISO 100

EXPOSURE:
1/25 second at f5.6

LIGHTING:
Daylight only

◀ *Although a strong colour, the blue of the background to this picture does not clash with the colour of the subjects' clothes – indeed, the contrast is strong enough to propel the boy and girl forward in the frame, creating a distinctly three-dimensional effect.*

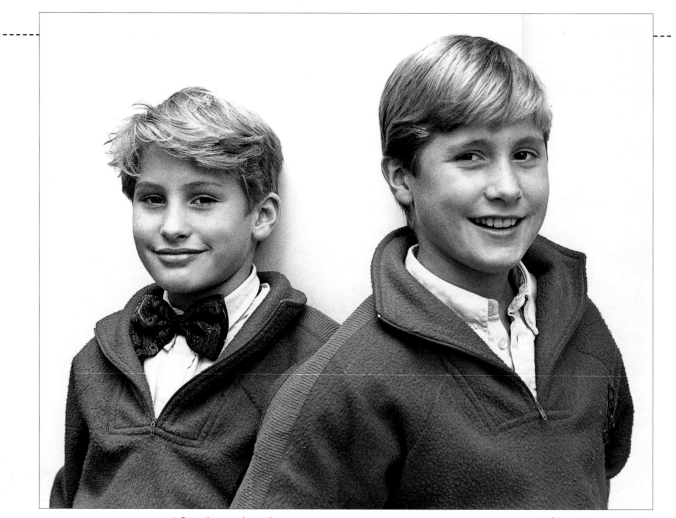

PHOTOGRAPHER:
Majken Kruse

CAMERA:
35mm

LENS:
105mm

FILM SPEED:
ISO 125

EXPOSURE:
⅟₆₀ second at f8

LIGHTING:
Daylight only

▲ *Even when you choose the simplest of background, such as the plain-painted walls in this double portrait, you still need to be aware of the intrusive effect that background texture can have. The photographer overcame the potential problem in this example by ensuring that the background was slightly overexposed. This, in effect, 'washed clean' the surface of any visual information.*

PHOTOGRAPHER:
Linda Sole

CAMERA:
6 x 7cm

LENS:
150mm

FILM SPEED:
ISO 100

EXPOSURE:
⅟₆₀ second at f4

LIGHTING:
Daylight only

▶ *If the setting you are shooting in is full of extraneous clutter, the subject can easily become lost in a mass of visual distractions. Here, the photographer solved the problem by posing her young subject against an unpainted fencing panel. She then cropped in tightly, using a moderate telephoto lens, to exclude everything else from the viewfinder frame. Tonal contrasts are vitally important in black and white, and here you can see how the contrast between the wooden fence and the subject's dress has been used to good creative effect.*

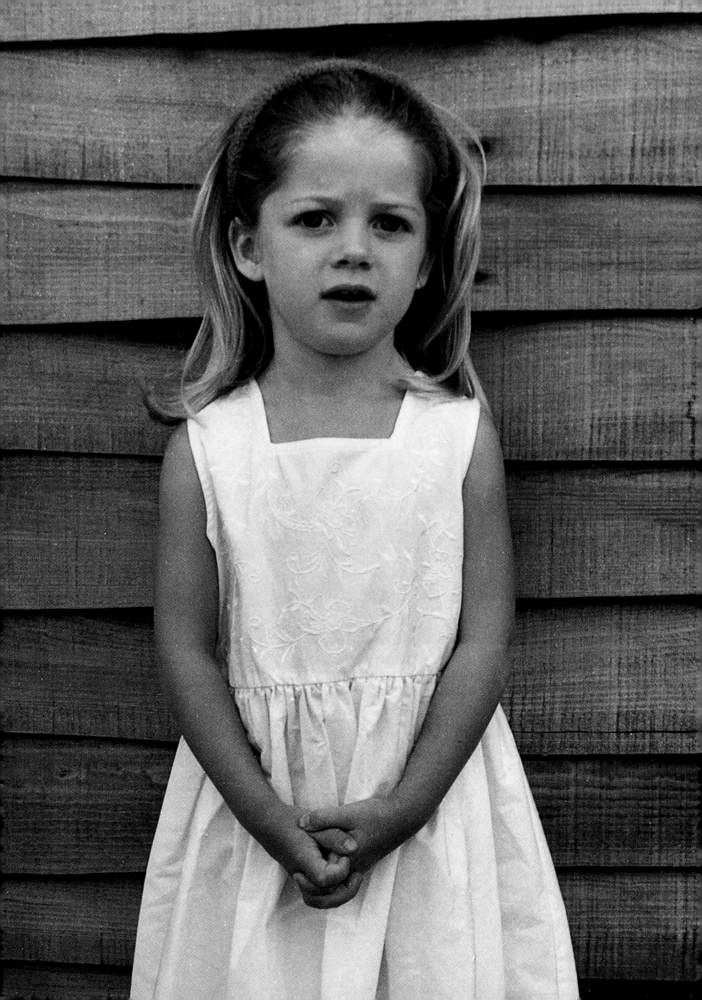

▲ By carefully angling the lighting heads used in a studio portrait session, and ensuring that your subject is well forward of any background paper or flats, you can create sufficient exposure difference between foreground and background so that the subject is effectively isolated. However, you will have to allow just enough light to spill past the subject and reach the background if you want some colour or tone to show – otherwise the figure will be shrouded in darkness.

PHOTOGRAPHER:	PHOTOGRAPHER:
LLewellyn Robins	**LLewellyn Robins**
CAMERA:	CAMERA:
35mm	**35mm**
LENS:	LENS:
80mm	**90mm**
FILM SPEED:	FILM SPEED:
ISO 50	**ISO 50**
EXPOSURE:	EXPOSURE:
¹⁄₆₀ second at f11	**¹⁄₆₀ second at f5.6**
LIGHTING:	LIGHTING:
Studio flash	**Studio flash**

▶ In this portrait, the photographer has made a positive asset of the background by showing the subject leaning against it. The large piece of canvas used was painted in a mottled blue and grey colour scheme that tones in with the girl's blue and green tartan outfit, and the sidelighting employed helps to bring out the texture in the backcloth. To emphasize the subject's eyes, the photographer asked the girl to look directly at her mother, who was standing just to the right of the camera.

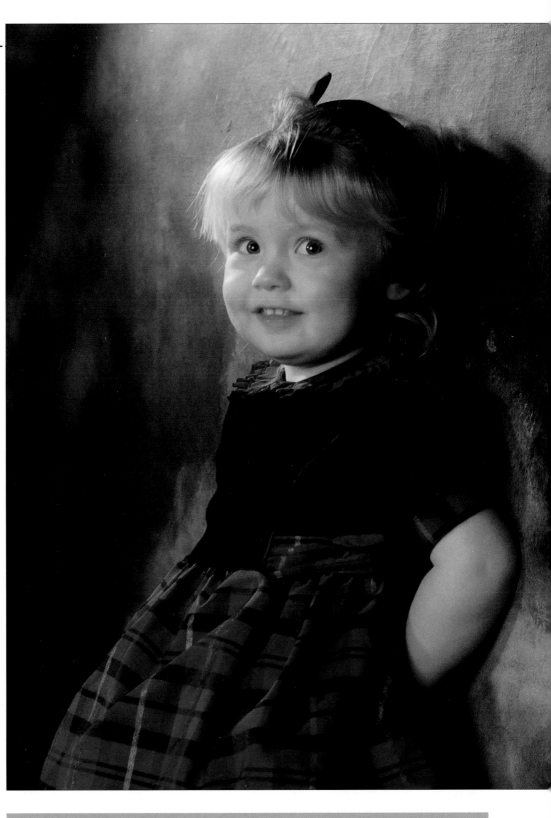

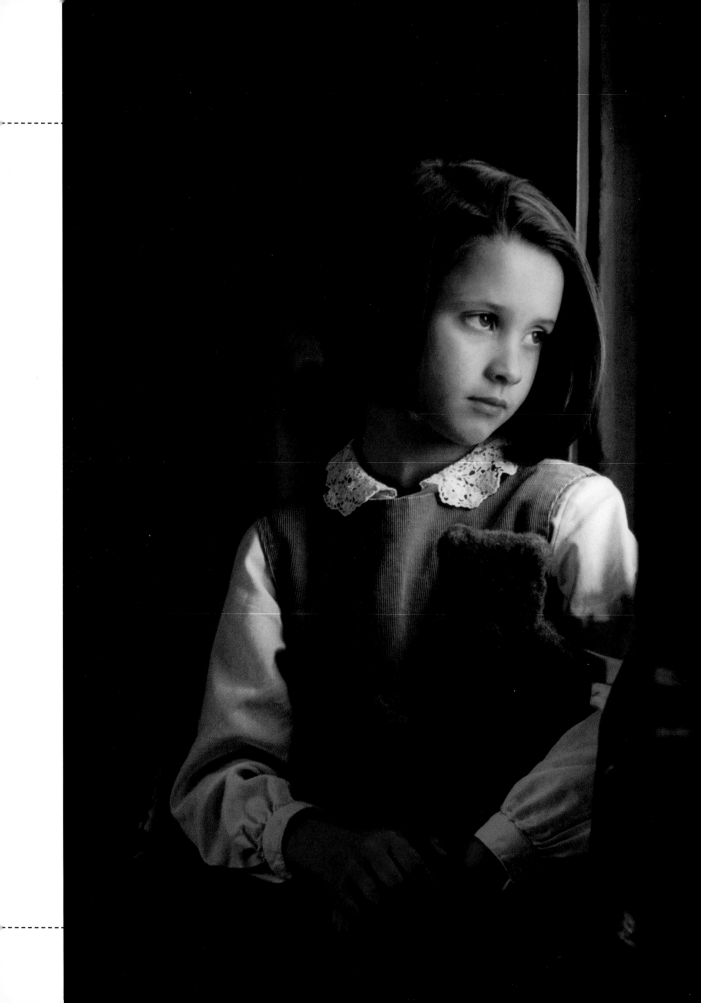

◀ *This seemingly daylight-illuminated portrait was created in the studio using entirely artificial light sources. By subduing the surroundings through underexposure like this, you need to use only a simple lighting set-up, and the results can be undetectable from the 'real thing'. Exposure was calculated entirely from the lit side of the subject's face, and no concessions were made to the shadow areas.*

PHOTOGRAPHER:
Llewellyn Robins

CAMERA:
35mm

LENS:
80mm

FILM SPEED:
ISO 50

EXPOSURE:
¹⁄₆₀ second at f8

LIGHTING:
Studio flash (fitted with softbox) and cardboard reflector

▲ *To create this 'daylit' scene, the photographer lined two studio flats with curtaining material, positioning the subject in the gap (simulating the window opening) between them. The light source was a single studio flash unit and softbox on the far side of the flats, placed out of sight of the camera. On the camera side of the flats, to the left of the camera position, a rectangular piece of white, rigid cardboard was angled to reflect a little light back into the shadows. The only other set dressing was a free-standing bookshelf just visible on the near side of the subject.*

FRAMING THE SUBJECT

The pictorial device of using frames within a photograph can serve a number of important purposes. They can be used to draw attention to a particular part of a composition, for example – most often to the area where the main subject is located. Equally, frames can be used to create a visual highlight that distracts attention from some part of an image that is making less than a positive contribution to the overall composition, such as a large expanse of flat and featureless sky; or you can use a line-of-sight effect to ensure that a frame completely masks some part of a scene that you don't want to record.

Even where such naturally occurring frames as doorways, arches, windows, shrubbery, and so on are not available, you can often create a frame by, say, holding a leafy branch close to the lens. Check its position in the viewfinder until you see that it occupies the desired area of the picture, and select a wide aperture to ensure that it is knocked sufficiently out of focus not to be distracting. Other types of frames can be parts of the subject's own body – long tresses of hair, for example, can form the perfect frame for the face if they are properly arranged, as can the subject's hands. Hats, scarves, and other articles of clothing, such as high collars, can also be used as frames for full-face close-ups.

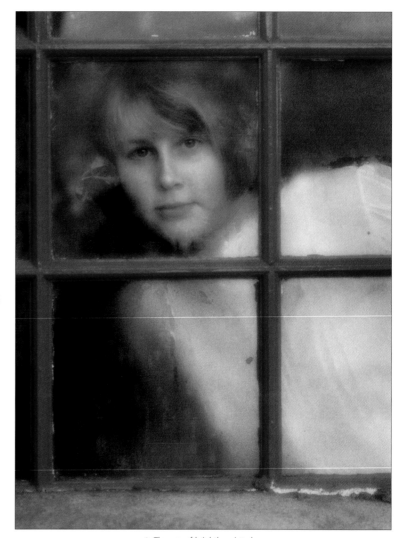

▲ The use of brightly painted window beadings to frame the subject has introduced a strongly graphic element into this portrait, but care has to be taken to ensure that you accurately align important parts of the subject with areas of clear glass. The slight condensation on the inside of the window has created an attractive, soft-focus effect.

PHOTOGRAPHER:
Tracy Turner

CAMERA:
35mm

LENS:
135mm

FILM SPEED:
ISO 50

EXPOSURE:
¹⁄₆₀ second at f5.6

LIGHTING:
Daylight only

▶ *Make-shift frames can be created from many types of ordinary objects. Here, the photographer has arranged a brightly coloured, red-checked travelling rug around the girl's head to help create a stronger contrast between the subject and the distant landscape. Without the rug, the girl's red hair was too similar in colour to the ruddy, out-of-focus background blur.*

PHOTOGRAPHER:
Ronald Turner

CAMERA:
35mm

LENS:
180mm

FILM SPEED:
ISO 50

EXPOSURE:
1/125 second at f3.5

LIGHTING:
Daylight and diffused accessory flash

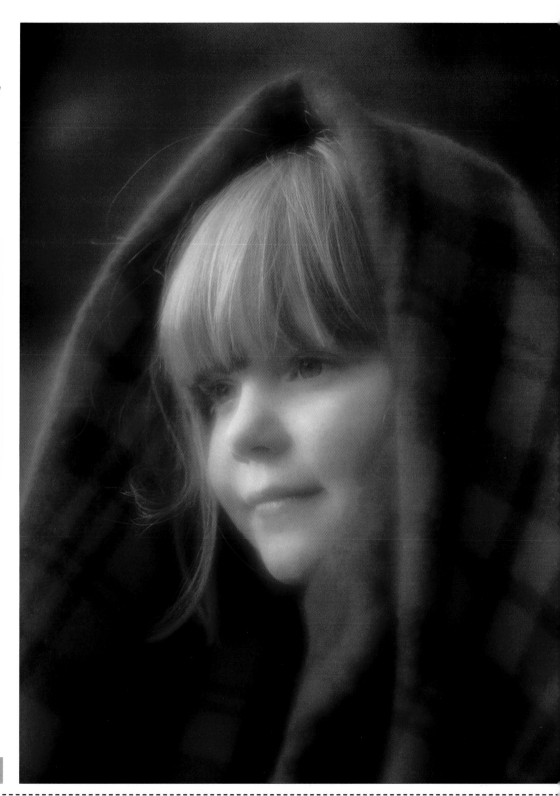

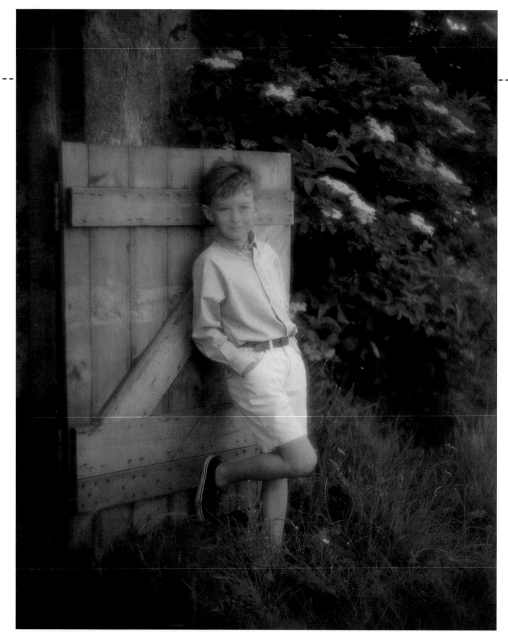

▶ For this portrait, the photographer has utilized a large, 19th-century free-standing mirror to frame the seated figure of a young girl. If you want to show both the subject and her reflection equally as sharp you may need to use a small aperture to increase depth of field. Alternatively, you could move in close to the subject, perhaps positioning her off to one side of the picture area, while focusing specifically on the reflected image and selecting a wide aperture. This should produce a well-focused reflection and an attractively soft image of the off-centre subject.

▲ In this example, the photographer has introduced a neutral area of woodwork in the form of a gate, to act as a frame in order to pull the subject visually well away from a highly detailed background of foliage and flowers. Take the frame away from the composition and the image would have less of an obvious focus for the viewer's attention.

PHOTOGRAPHER:
Ronald Turner

CAMERA:
35mm

LENS:
50mm

FILM SPEED:
ISO 50

EXPOSURE:
½₅₀ second at f16

LIGHTING:
Daylight only

PHOTOGRAPHER:
Ronald Turner

CAMERA:
35mm

LENS:
80mm

FILM SPEED:
ISO 50

EXPOSURE:
½₅₀ second at f4

LIGHTING:
Daylight only

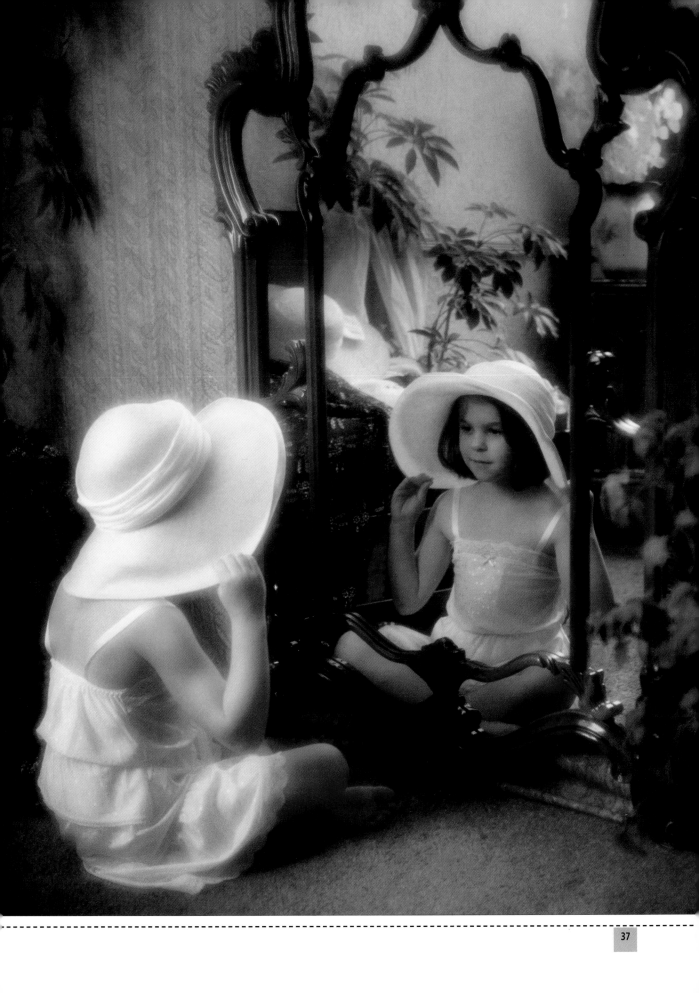

BABIES AND TODDLERS

Starting work on a bare set with your young subjects and their parents waiting for you to 'perform' can be daunting. Just where do you start?

As you become more experienced with photographing babies and young children, so your repertoire of solutions grows. The first strategy is to stay relaxed – any tension you feel about the situation will be quickly transmitted to all about you. Second, depending on the age of the child, decide on your basic photographic approach – if this involves using some sort of prop, such as a chair to prop babies up in or as a support for those a little older but not yet too steady on their feet, place it on the set and start arranging your lights in relation to it. You should be able to set, at least approximately, the main light and sidelight before you even call your subject into position. Once in position, fine-tune the lighting heights and directions and make any final adjustments quickly before starting to shoot. The quicker you can work, the less time there will be for your subject to become fractious.

WARNING

If you have a child unattended climbing on a lightweight chair, make sure that it is firmly fixed to the floor so that it cannot overbalance. If the legs of the chair will be visible in the picture, fixings need to be invisible. Likewise with a folding chair – before allowing a child to use it as a prop, the chair has to be fixed permanently and safely in an open position.

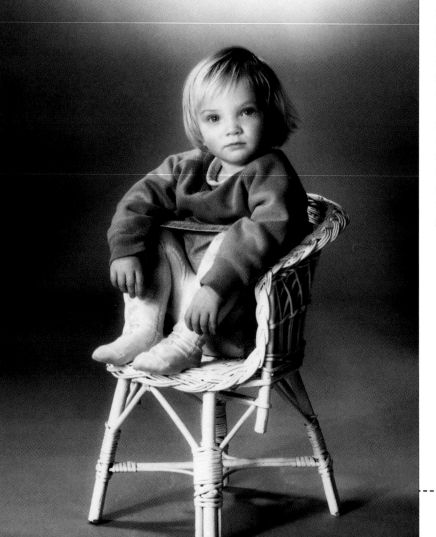

◀▶ *You never know how a child will react to a photographer's studio. Sometimes it's all tears, sometimes all laughs. The young lady seen here simply found all of the strange equipment and new people fascinating. Once the chair had been placed in position and the lights arranged around it, she confidently sat down and ran through a series of different poses and proved very responsive to the photographer's prompting.*

PHOTOGRAPHER:
Desi Fontaine

CAMERA:
35mm

LENS:
85mm

FILM SPEED:
ISO 100

EXPOSURE:
⅟₆₀ second at f16

LIGHTING:
**Studio flash x 3
(2 fitted with softboxes)**

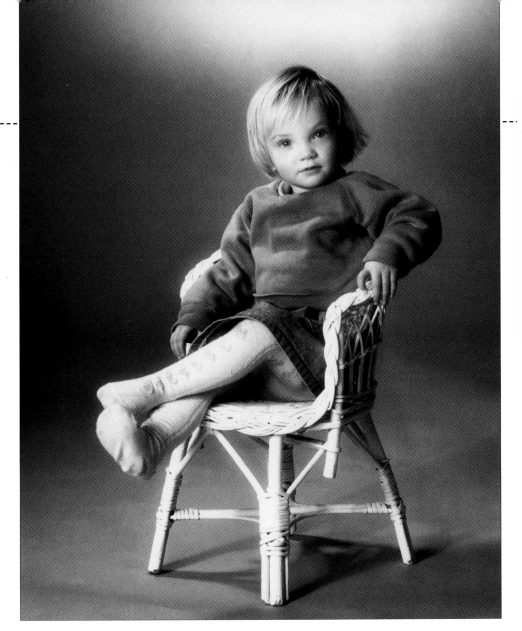

PHOTOGRAPHER:
Desi Fontaine

CAMERA:
35mm

LENS:
85mm

FILM SPEED:
ISO 100

EXPOSURE:
⅟₆₀ second at f16

LIGHTING:
**Studio flash x 3
(2 fitted with softboxes)**

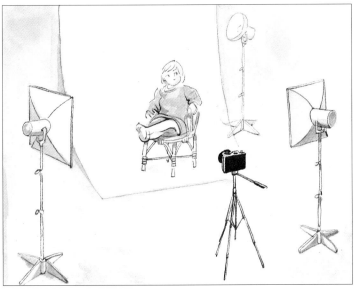

◀ *The principal light for these portraits was a studio flash fitted with a softbox diffuser to the left of the camera position. Slightly closer to the subject, but more frontally on and to the right of the camera, another flash and softbox were used to reduce facial contrast. This light, however, was powered down to only one-third the output of the principal light. Finally, a third, undiffused flash was used behind and to one side of the subject to produce the glowing highlight seen on the background paper above the little girl's head.*

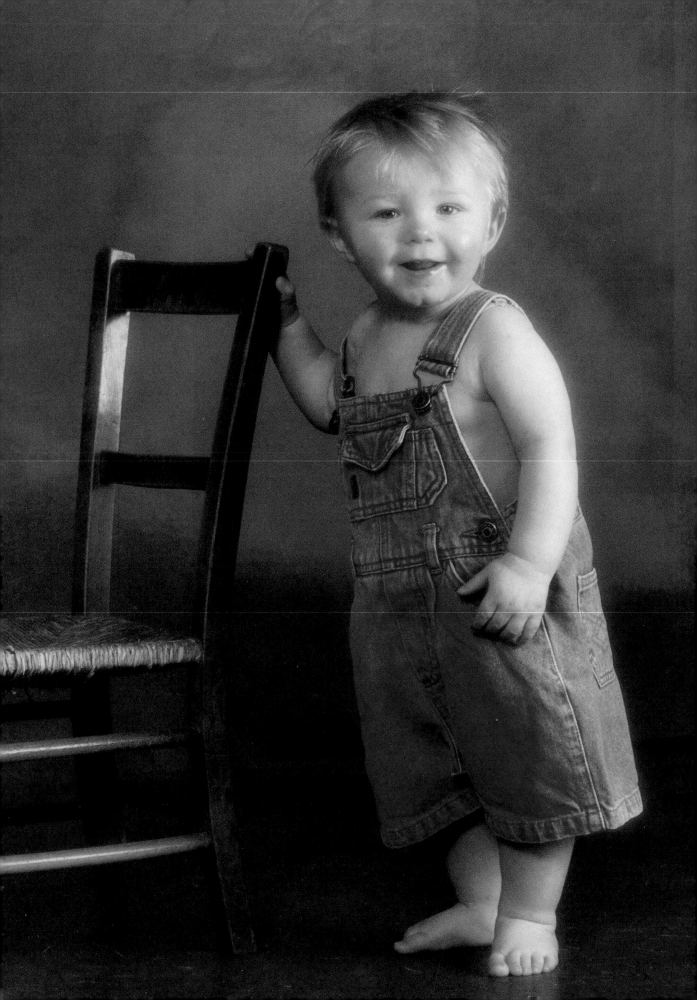

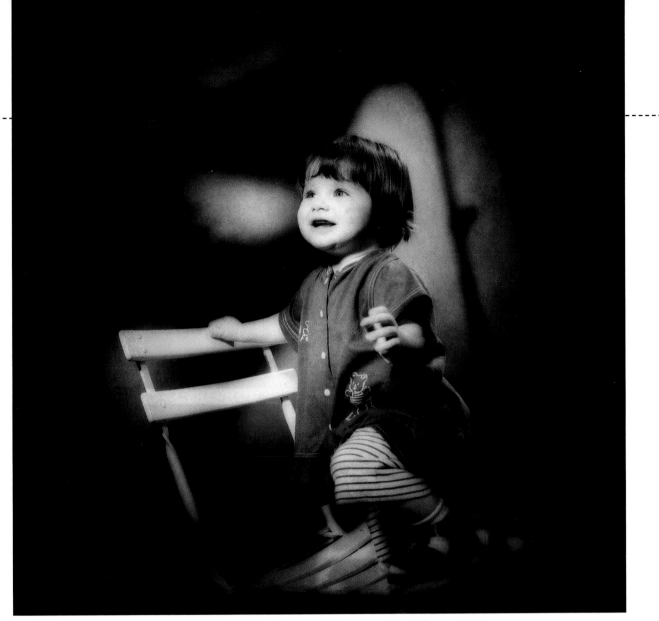

▲ The high back to this chair gives the young child essential support and encourages her to be quite confident in her movements. An essential element of this composition is the projected shadow on the rear background paper. This was produced by inserting a shaped piece of cardboard into a holder in front of the lighting head of a tungsten spotlight.

PHOTOGRAPHER:
Llewellyn Robins

CAMERA:
35mm

LENS:
120mm

FILM SPEED:
ISO 50

EXPOSURE:
¹⁄₆₀ second at f11

LIGHTING:
Studio flash x 2 (1 fitted with softbox)

◄ The mellow colour and interesting textures of this type of chair make a positive contribution to the image. It is also heavy and stable enough to be used as a free-standing prop.

PHOTOGRAPHER:
Jos Sprangers

CAMERA:
6 x 6cm

LENS:
150mm

FILM SPEED:
ISO 100

EXPOSURE:
¹⁄₆₀ second at f11

LIGHTING:
Tungsten spotlights x 2 (1 fitted with cardboard shape for background) and tungsten floodlight x 1 fitted with umbrella reflector

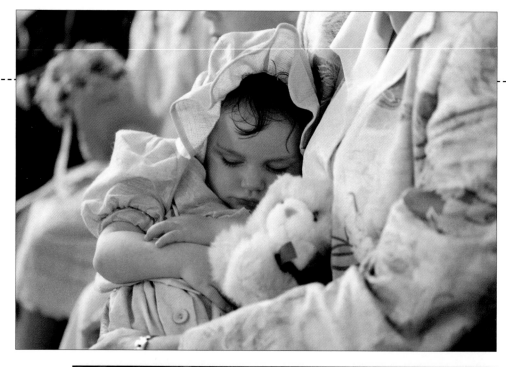

◀ ▶ *Before children are fully confident on their feet it is vital that you provide some sort of support for them to use, unless you want to include their parents in the shot. In this off-the-cuff portrait, the young subject fell fast asleep in the registry office during a wedding ceremony. The initial, full-frame version (above left) shows a rather confused and cluttered image, with too much background sufficiently in focus and the subject rather lost somewhere in the middle of it all. In the cropped version, however (right), a lot of the clutter has been swept away, and the composition is stronger and more coherent as a result.*

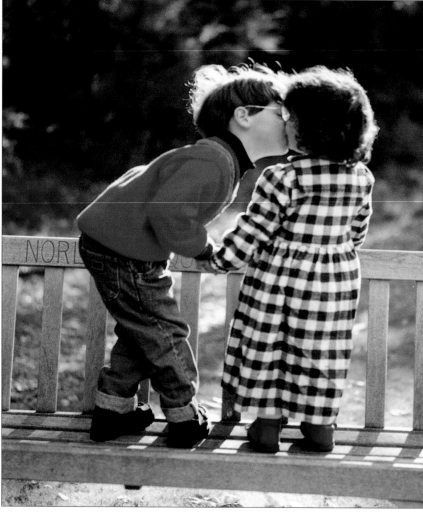

PHOTOGRAPHER:
Majken Kruse

CAMERA:
35mm

LENS:
90mm

FILM SPEED:
ISO 200

EXPOSURE:
⅟₆₀ second at f8

LIGHTING:
Daylight only

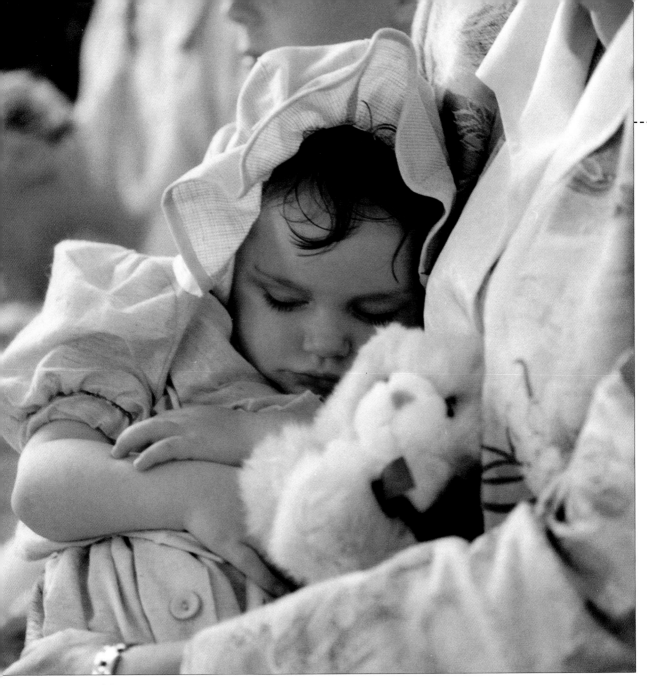

◀ With youngsters of this age, it helps to elevate them from the ground, since getting down to their eye level means shooting from a kneeling position. When your subjects are backlit, as they are here, underexposure is always a possibility unless you compensate. Taking a selective light reading from a shadowy part of the scene gives you a better guide to settings than a general reading, which may be over influenced by the highlights.

PHOTOGRAPHER:
Anne Kumps

CAMERA:
35mm

LENS:
70mm

FILM SPEED:
ISO 100

EXPOSURE:
¹⁄₆₀ second at f4

LIGHTING:
Daylight only

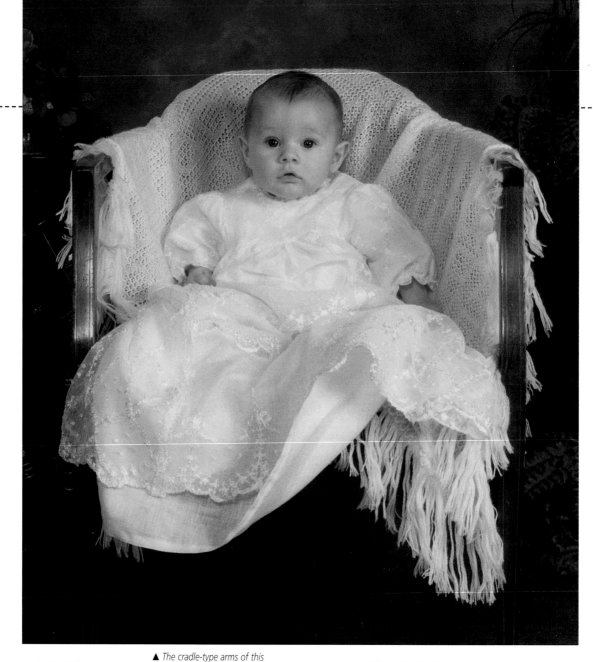

▲ The cradle-type arms of this chair, which is largely covered in a baby's shawl, makes a set within a set, creating a comfortable, secure, and enclosed space within which to pose this baby, who was brought to the studio immediately after his christening service to have his first portrait picture taken.

PHOTOGRAPHER:
Llewellyn Robins

CAMERA:
35mm

LENS:
70mm

FILM SPEED:
ISO 50

EXPOSURE:
⅟₆₀ second at f22

LIGHTING:
**Studio flash x 2
(both fitted with softboxes)**

PHOTOGRAPHER:
Anne Kumps

CAMERA:
35mm

LENS:
105mm

FILM SPEED:
ISO 100

EXPOSURE:
⅟₆₀ second at f11

LIGHTING:
**Studio flash x 2
(1 fitted with a snoot)**

▶ Often young children are brought to the studio dressed in pastels, white, or neutral colours. This little girl, however, was dressed in an intense red, offset with black and a touch of turquoise. To make the most of the startling colour potential, the photographer deliberately underlit some of the frame to intensify the colour content still further, using a studio flash fitted with a snoot to confine the light output principally to the face.

A STUDIED APPROACH

Although difficult to define, we all instinctively recognize a portrait in which the photographer has managed to convey the character of the subject rather than simply a physical likeness. There may be things about the composition you don't particularly like or would have interpreted differently, but still the subject reaches out of the frame and grabs your attention.

The pictures presented here, and those on the following pages, display a wide range of approaches to the subject. Some are strictly formal, although taken outdoors, and are the result of chance encounters, while others are contrived studio studies or portraits taken in the client's home. Each one, however, communicates to the viewer some aspect of the characters of the children portrayed and displays the photographers' careful attention to the entire composition.

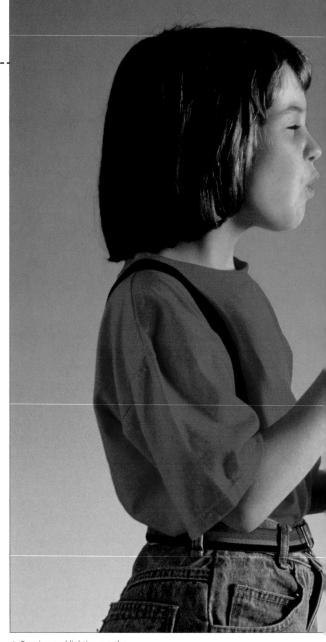

PHOTOGRAPHER:
Peter Millard

CAMERA:
35mm

LENS:
75mm

FILM SPEED:
ISO 200

EXPOSURE:
¹⁄₁₂₅ second at f16

LIGHTING:
**Studio flash x 3
(2 fitted with softboxes)**

▲ *Framing and lighting are the vital ingredients of this shot's success. The strongly horizontal framing, with the subject positioned at the extreme edge of the picture area, gave the photographer maximum leeway to capture the long train of soap bubbles stretching away from the hoop. The lights were also carefully set so that the shapes of the bubbles were clearly defined by the catchlights you can see.*

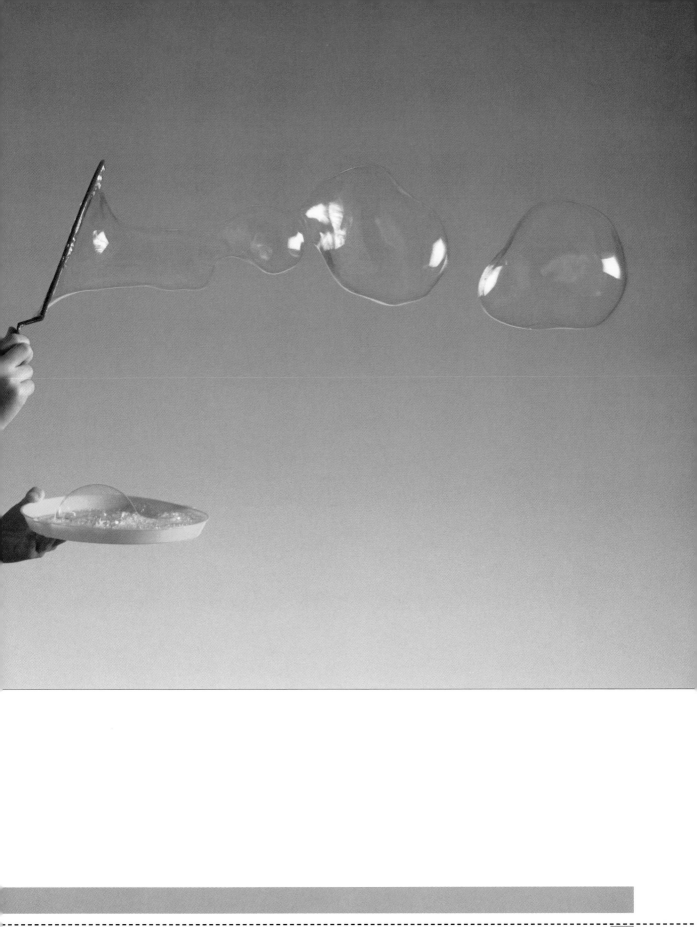

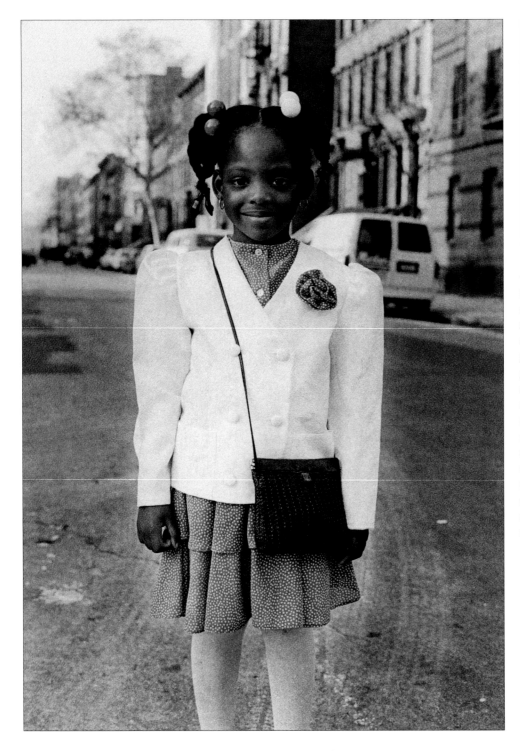

PHOTOGRAPHER:
Linda Sole

CAMERA:
6 x 4.5cm

LENS:
85mm

FILM SPEED:
ISO 200

EXPOSURE:
½₂₅₀ second at f4

LIGHTING:
Daylight only

◀ *Looking smartly dressed for church early on a Sunday morning, and only slightly self-conscious in front of the camera, this young girl was pleased to give the photographer a few minutes so that she could take her picture. By positioning the girl well in front of any buildings, and with the street empty of traffic, the photographer was able to show enough of the setting to give the subject a proper context, while softening its impact by taking it out of focus with a large aperture.*

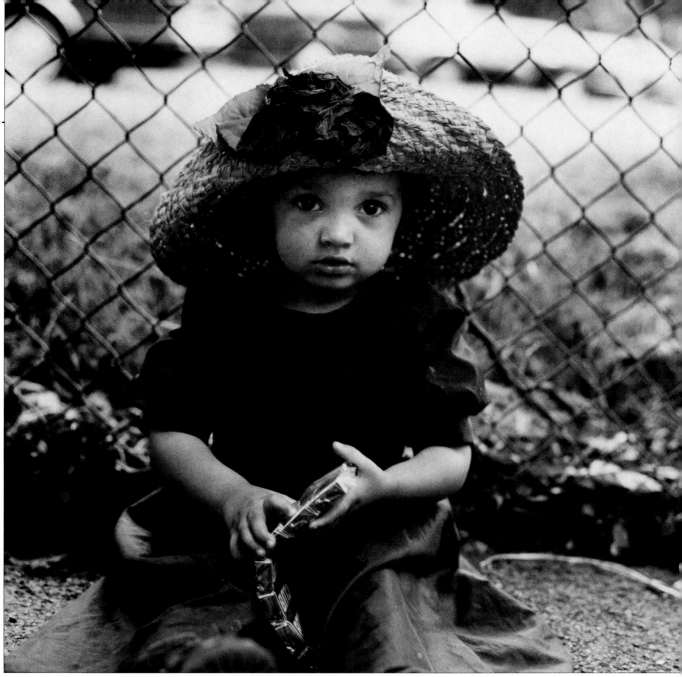

PHOTOGRAPHER:
Linda Sole

CAMERA:
6 x 4.5cm

LENS:
150mm

FILM SPEED:
ISO 400

EXPOSURE:
⅟₆₀ second at f4

LIGHTING:
Daylight only

▲ *A chance encounter at a street market led to this portrait. The photographer noticed the little girl sitting against a wire fence at the rear of her parents' stall. As the photographer quickly squatted, to bring the camera down to the child's eyeline, and adjusted the aperture to throw the background out of focus, the child looked up directly into the camera lens.*

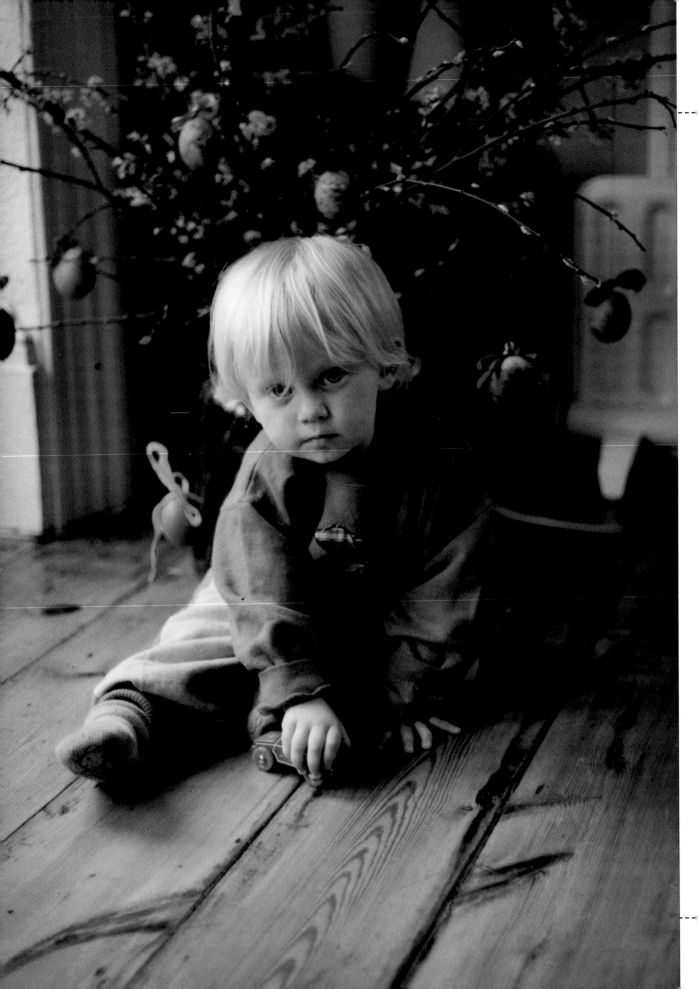

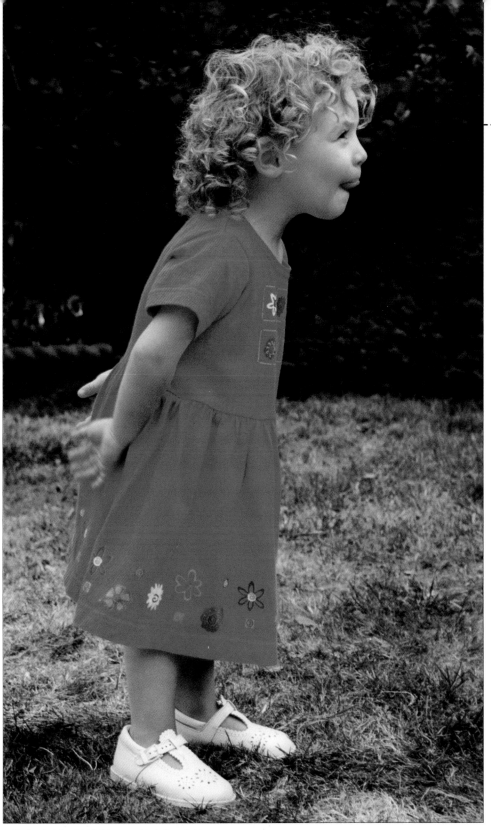

PHOTOGRAPHER:
Robin Dance

CAMERA:
35mm

LENS:
35mm

FILM SPEED:
ISO 125

EXPOSURE:
¹⁄₆₀ second at f2

LIGHTING:
Daylight only

◄ *When working in the client's home, as opposed to a studio, you have to relinquish some control over the setting. To set this shot up, the photographer first positioned the vase of dried flowers to mask the corner of the room and then lay flat on the floor. This was not only to match approximately the subject's eyeline but also to emphasize the direction of the polished floorboards. By using the floorboards as lead-in lines, attention is immediately riveted on the subject.*

PHOTOGRAPHER:
Peter Millard

CAMERA:
6 x 4.5cm

LENS:
120mm

FILM SPEED:
ISO 100

EXPOSURE:
¹⁄₂₅₀ second at f5.6

LIGHTING:
Daylight only

▲ *Finding just the right lighting effect and then getting the subject into position before clouds obscured the sun has given us this portrait. The slight forward tilt of the subject, the mischievous tongue protruding from her mouth, and the hands held behind her back all combine to give the impression of a happy and lively personality.*

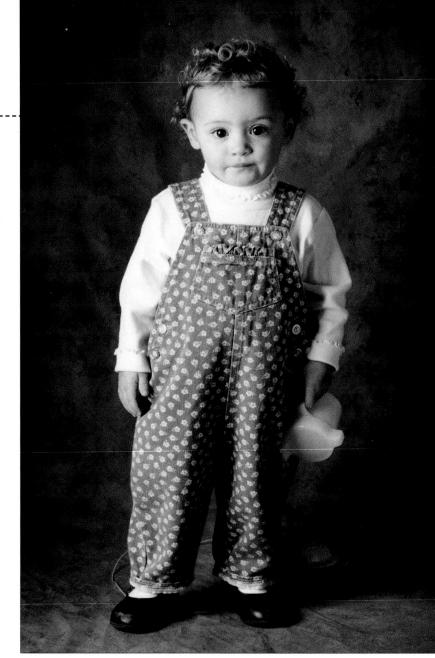

▶ By restricting the range of colours in this studio portrait, the photographer has minimized any potential distractions, and so strengthened the overall composition. The chair helps to steady the little girl, giving her the confidence she needed to relax in front of the camera. The teddy bear, the subject's own toy, acts both as a comforter and as a device for justifying the chair being included in the shot.

PHOTOGRAPHER:
Desi Fontaine

CAMERA:
6 x 6cm

LENS:
120mm

FILM SPEED:
ISO 50

EXPOSURE:
⅟₆₀ second at f16

LIGHTING:
**Studio flash x 2
(both fitted with softboxes)**

PHOTOGRAPHER:
Peter Millard

CAMERA:
6 x 4.5cm

LENS:
105mm

FILM SPEED:
ISO 200

EXPOSURE:
⅟₆₀ second at f22

LIGHTING:
**Studio flash x 2
(both fitted with softboxes)**

▲ Careful consideration was given to setting up this shot, with the photographer deciding on a darkly neutral but interestingly toned background to contrast with the young subject's white top. In order to keep the subject's attention fixed firmly on the camera, the little girl's mother stood alongside the photographer throughout the session.

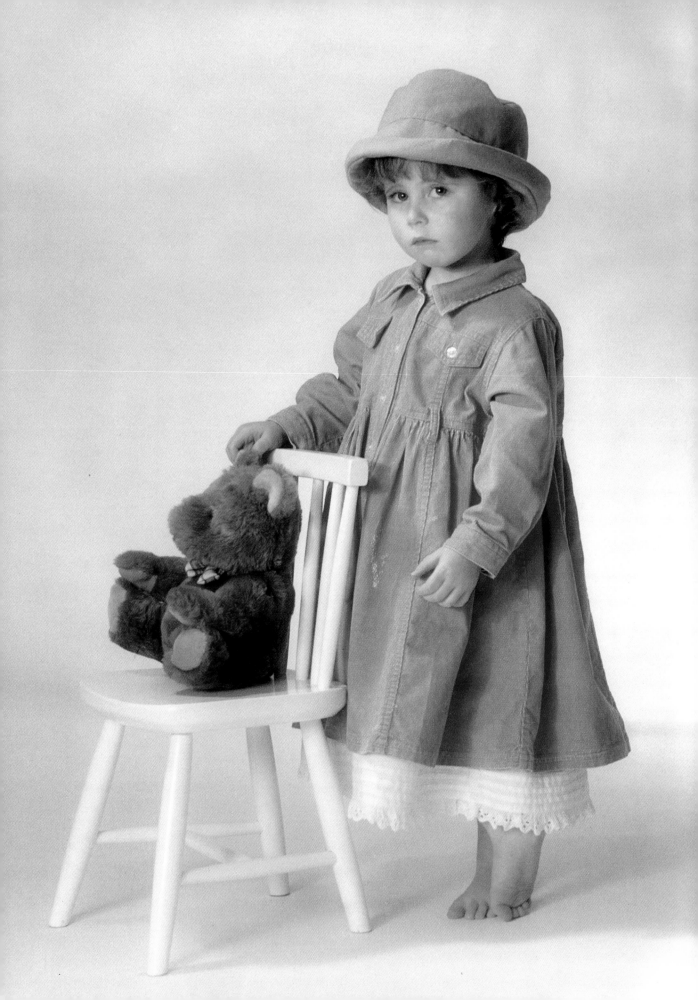

PLACING THE FIGURE

It is not only the qualities of the subject that determine how successful a particular portrait is – good pictures also depend on the way the photographer places the subject, or subjects, within the image area. Part of this process of composition involves the photographer deciding, often quite instinctively, what to include in the frame and what to omit.

Nobody would suggest that there are rules of composition that, if assiduously applied, will guarantee good results. There are, however, some guidelines that may help you. Centrally placed figures, for example, tend to produce a static type of composition, while figures placed to the left or right of the frame tend to imply activity and action. If you are using the extreme edges of the frame, it is often best to show your subject looking across the picture area into the available space rather than looking out of the frame.

If you are shooting on a 35mm or medium format, or rollfilm, camera (apart from the 6 x 6cm format), you have a choice of shooting a horizontally or vertically framed image. Horizontal images help to direct the eye of the viewer across the image area, relating the left and right of the frame. Vertical images, on the other hand, help to direct the viewer's eye into the picture, relating more strongly the foreground and the background.

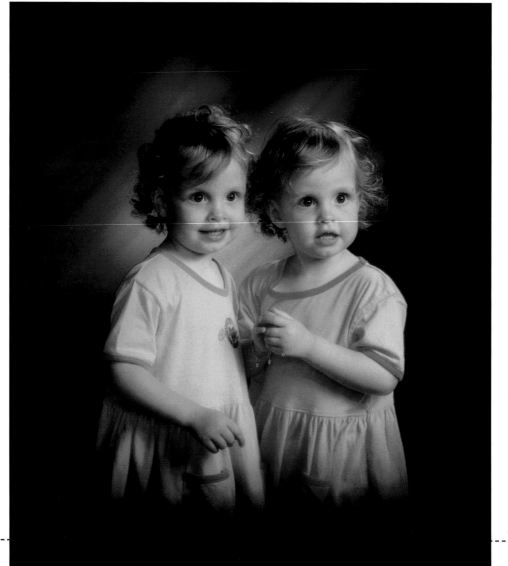

PHOTOGRAPHER:
Jos Sprangers

CAMERA:
6 x 7cm

LENS:
125mm

FILM SPEED:
ISO 50

EXPOSURE:
1/30 second at f22

LIGHTING:
Tungsten spotlight and floodlight (fitted with an umbrella reflector)

◀ *Centrally framed and picked out by a spotlight in an otherwise darkened set, these two little girls have been composed in this way at the request of their parents, who wanted exactly this type of image as a family record. Even when the interpretation of the subject(s) is dictated by the client, you cannot let the technical side of your photography slip.*

▶ A powerful composition, and one that is full of interest, has resulted from the photographer positioning the subject at the extreme edge of the frame. Other aspects of the composition that are instantly eye-catching are the well-defined diagonal bands of light and dark tone, represented by the different-coloured segments of the circus tent, and the large star shape high up in the frame. The star not only acts to balance the young girl who is positioned diagonally opposite, its shape also echoes the motif seen on the subject's dress.

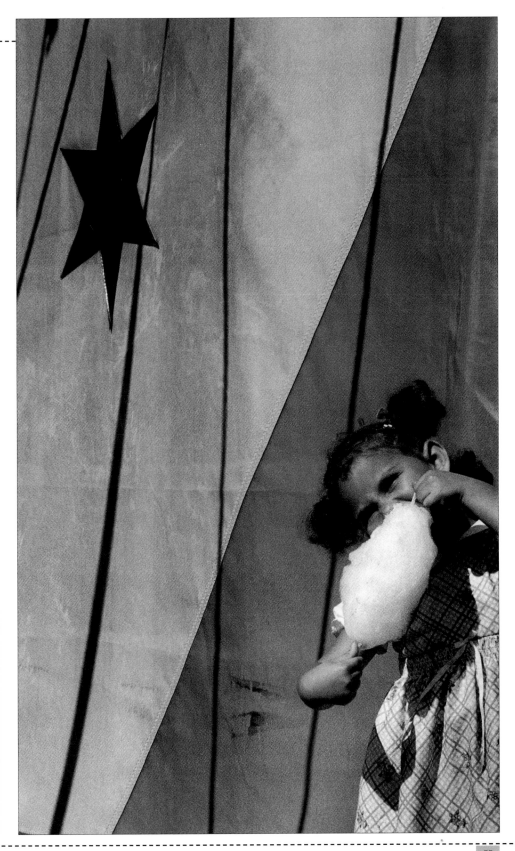

PHOTOGRAPHER:
Nicholas Sinclair

CAMERA:
35mm

LENS:
28mm

FILM SPEED:
ISO 200

EXPOSURE:
½₅₀ second at f8

LIGHTING:
Daylight only

◄ Here, the photographer has used the sides of the frame to create an active and dynamic composition, with the horizontal framing strongly relating the left and right sides of the image. This is exactly what was needed to distract attention away from the expanse of autumn leaves carpeting the ground from the foreground through to the background.

PHOTOGRAPHER:
Majken Kruse

CAMERA:
35mm

LENS:
300mm

FILM SPEED:
ISO 100

EXPOSURE:
¹⁄₂₅ second at f5.6

LIGHTING:
Daylight only

▲ Intersection of thirds
One of the more useful rules of composition is known as the intersection of thirds. If you imagine that the frame is divided up horizontally and vertically into thirds, then any subject element positioned on one of those lines is empha- sized, with particular emphasis given to anything positioned on any of the points where the lines intersect.

INFORMAL GROUPS

nlike a formal group photograph, which usually conveys the function of the group (a sports team, for example, school band, or hobby group) and has an obvious compositional structure, an informal or candid group picture may capture what is merely a transitory link between otherwise unconnected individuals. It may be an interest in you, or at least in the presence of your camera, that brings the group together and makes the photograph a success.

When you are working informally with groups of children, you cannot afford to be too rigid in your ideas – go with the flow, stay alert to any opportunities that present themselves, and don't be afraid of shooting more film than you think you will need.

If, however, even a temporary cohesion fails to materialize you may then have to take more of a direct approach by, say, introducing a subject of conversation that is likely to spark a reaction among the children. This could be a controversial comment on the merits of their local football or basket-ball team, for example, something they are all likely to have an opinion about from television or the movies, or something of topical interest in the local neighbourhood.

PHOTOGRAPHER:
Linda Sole

CAMERA:
35mm

LENS:
50mm

FILM SPEED:
ISO 400

EXPOSURE:
¹⁄₂₅₀ second at f8

LIGHTING:
Daylight only

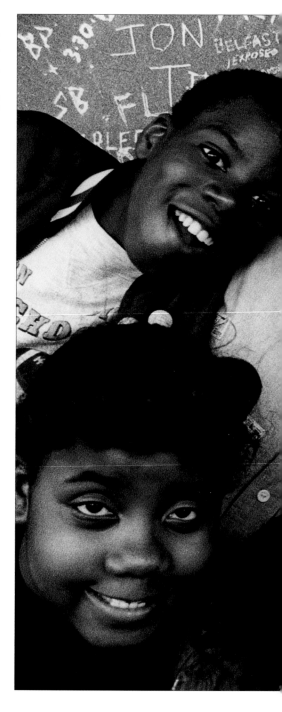

▶ *The rowdy high spirits of this informal group of children is evident in their good-natured pushing, shoving and flailing arms. The thing that united this group and gave it a strong compositional structure was each individual's attempt to get to centre stage before the picture was taken.*

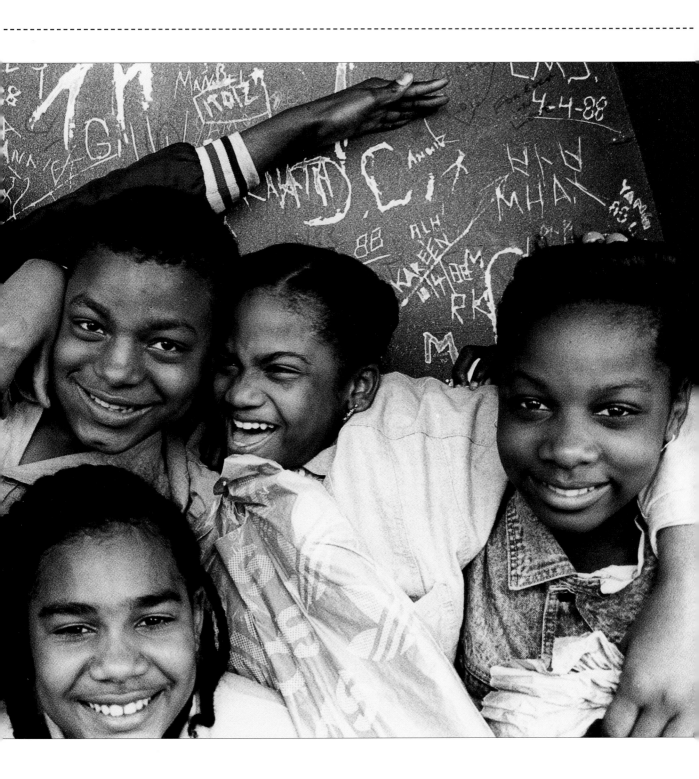

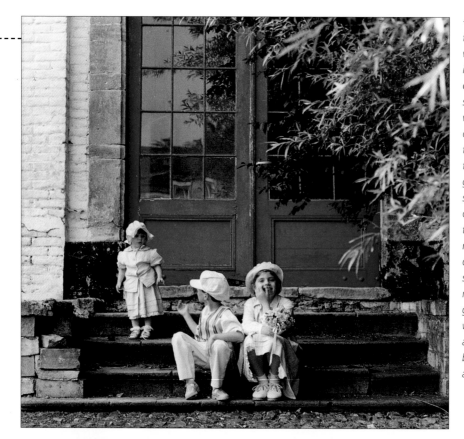

◀ ▶ *Having slipped away from the wedding reception that was in full swing in the building behind them, this group of children couldn't, however, shake off the photographer, who came across them sitting on the back steps. Although the older children were aware that they were being photographed, their attention was soon taken away from the camera and directed more towards the little girl, who was not fully confident climbing down the stone steps by herself. Although both pictures make interesting informal group portraits, the one in which the young girl receives a helping hand (right) shows better group cohesion and is a stronger composition.*

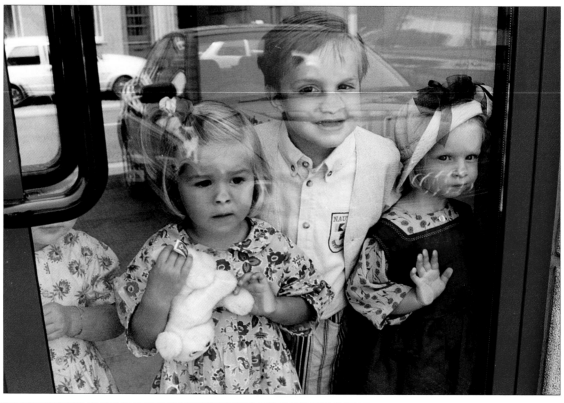

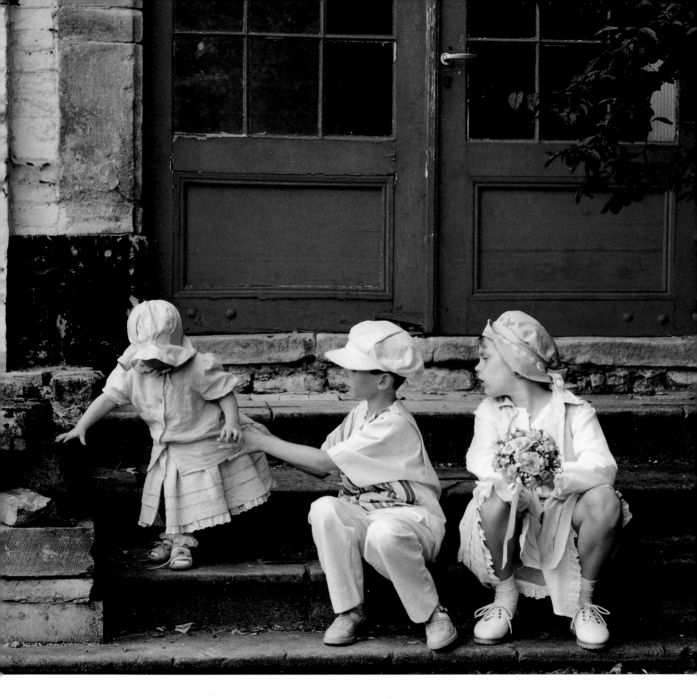

◀ The opportunity to take this humorous group portrait lasted only a second or two as the children all squashed their noses up against a glass door at the same time, so the photographer had to respond quickly. The ghostly reflection of the car in the street outside adds to the candid informality of the image, but the photographer was careful not to include her own reflection in the glass door.

PHOTOGRAPHER:
Anne Kumps

CAMERA:
35mm

LENS:
80mm

FILM SPEED:
ISO 100

EXPOSURE:
¹⁄₂₅ second at f11

LIGHTING:
Daylight only

PHOTOGRAPHER:
Anne Kumps

CAMERA:
6 x 6cm

LENS:
120mm

FILM SPEED:
ISO 100

EXPOSURE:
¹⁄₆₀ second at f8

LIGHTING:
Daylight only

FORMAL PAIRS AND GROUPS

There is no need to define formal portraiture too precisely – it is enough to say that any subject or group of subjects – either indoors or outside – posed specifically for the camera represents a formal portrait. When more than a single subject is involved, however, the implication of a formal portrait is that there is a common connection between all those depicted, some link that explains why they are in the same picture together. Perhaps all of the children are members of the same family, or they may all be members of a sporting or athletics team, band members, or class mates.

When posing a large group of children it is often worthwhile shooting some film while the subjects are still sorting themselves out – there is always a chance of recording one of those transitory arrangements that is amusing or revealing in some way, when the subjects are less guarded in their body language and facial expressions.

In the studio when you are using artificial lighting, make sure that any lighting units placed off-centre do not result in shadows from one subject being cast over important parts of another. And if you are using more than one light – as is likely to be the case – check before taking the shot that all the shadows that can be seen through the camera's viewfinder are being cast in the same direction. Conflicting shadows are unnatural and, thus, often distracting in a photograph, drawing attention away from the subjects themselves.

It is easy to see how the shadows are falling when using tungsten lighting units, since their light output is continuous. With studio flash, however, you have to use the built-in modelling lights (if available) in order to preview at least an approximation of the final lighting effect. If your flash units don't have these modelling lights, position desk lamps at the same height and

pointing in the same direction as the flash heads – you will need one lamp for each head, however, in order to gain a good impression of the fall of light and shade.

Another point to bear in mind when shooting pairs and groups is that the more people there are the more difficult it is to record each and every face clearly and attractively. For example, if you take only one or two shots you are bound to discover – once the film is processed – that one of your subjects is blinking at the critical moment or that somebody is looking away or stifling a yawn. Therefore, shoot enough frames to give yourself a good safety margin – the extra film and processing costs involved will be far less than having to gather the group back together at some later stage and re-shooting the entire session. Not only is re-shooting expensive, you also run the risk of damaging your reputation and forfeiting goodwill.

▶ *To light this double portrait, one studio flash unit fitted with a diffusing screen was positioned to the right of the camera, its height adjusted to the eyeline of the children. In addition, an accessory flashgun was mounted in the camera's hot shoe to introduce a little undiffused light and relieve the darker shadows falling on the subjects' faces. The background paper was far enough back not to catch any of the light spilling past the subjects.*

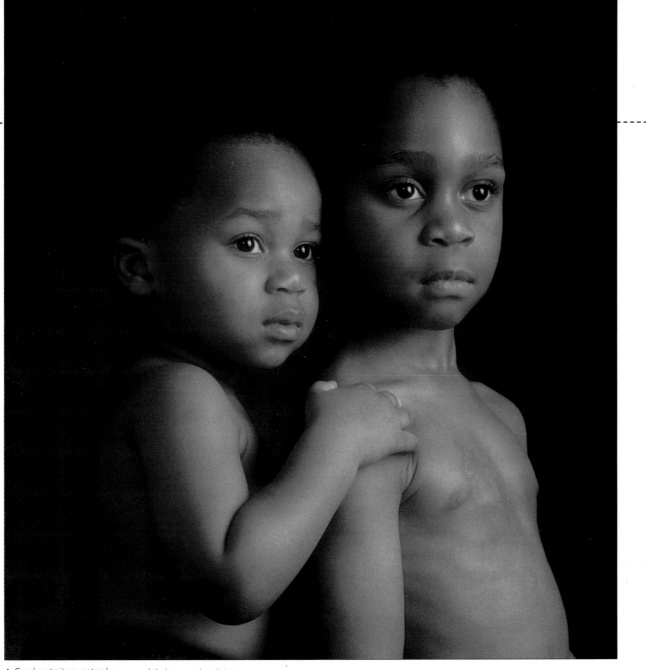

▲ Good portraiture, not only of children but also of adults, should try to get under the skin to show more than physical likeness. Although the two brothers shown here are only very young, the photograph has managed to record the serious side of their natures. Their faces are full of interest and their expressions intense, and you are drawn to wonder what they were thinking of when the picture was taken. The simple gesture of the younger boy in resting his hand on his big brother's shoulder speaks volumes of the affection and bond that exists between them.

PHOTOGRAPHER:
Llewellyn Robins

CAMERA:
6 x 4.5cm

LENS:
120mm

FILM SPEED:
ISO 50

EXPOSURE:
¹⁄₆₀ second at f11

LIGHTING:
Undiffused accessory flash and diffused studio flash

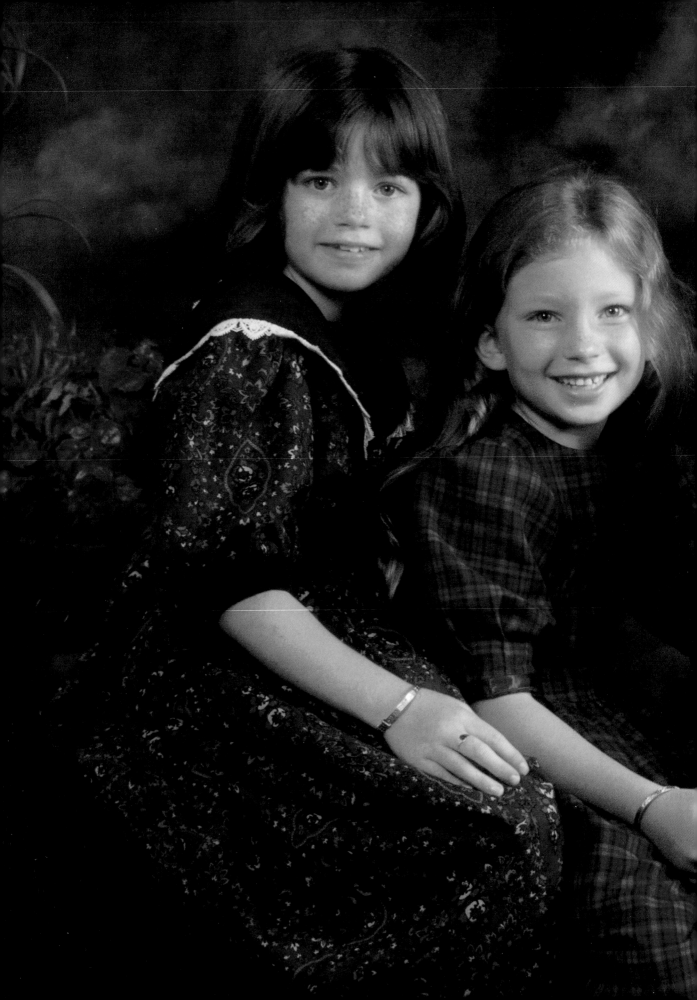

◄ *Many parents commission family portraits of their children of this type. And because it is of a 'type', it is even more important that you make the final image 'sparkle' by injecting something special into the image. Here, the photographer has dressed the set attractively, matching the style of the props to the children's clothing and picking up on colours and repeating them to good effect – the green of the centre girl's tartan with the green of the plants, for example. Note, too, how much care has been taken with the positions of the older girls' arms and hands, directing the eye across the composition to the youngest girl on the right.*

PHOTOGRAPHER:
Llewellyn Robins

CAMERA:
6 x 4.5cm

LENS:
105mm

FILM SPEED:
ISO 50

EXPOSURE:
¹⁄₆₀ second at f16

LIGHTING:
**Studio flash x 3
(2 fitted with softboxes)**

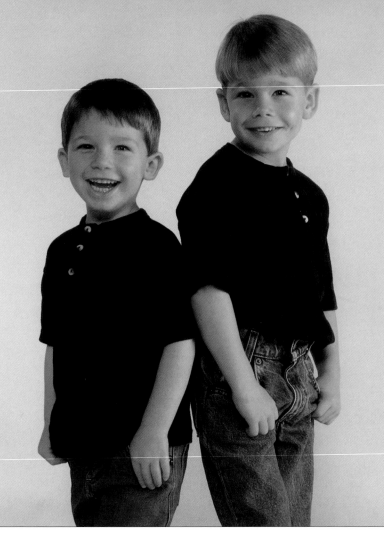

◀ Blue denims and dark blue (almost black) t-shirts required careful attention to background colours and tones. A dark-coloured or over-detailed background could cause the subjects to be sucked into the image, merging with their surroundings and producing a more moody type of lighting effect. Here, however, the photographer decided to lighten the mood by throwing the subjects well forward in the frame by showing them against a plain, off-white background paper lit separately with a small flash unit (fitted with a diffuser) positioned low down just behind the boys.

PHOTOGRAPHER:
Llewellyn Robins

CAMERA:
6 x 4.5cm

LENS:
120mm

FILM SPEED:
ISO 50

EXPOSURE:
1/125 second at f16

LIGHTING:
**Studio flash x 3
(2 fitted with softboxes,
1 with diffuser)**

PHOTOGRAPHER:
Llewellyn Robins

CAMERA:
6 x 4.5cm

LENS:
105mm

FILM SPEED:
ISO 50

EXPOSURE:
1/60 second at f16

LIGHTING:
**Studio flash x 2
(both fitted with softboxes)**

▶ One of the perennial problems photographers face with portraits of pairs and groups of subjects with a range of ages and, hence, heights, is how to bring all the faces up to approximately the same level while not creating an uncomfortable and forced-looking composition. In this example, the photographer has seated the girl in a natural pose on the floor and positioned her young brother in a kneeling position behind her.

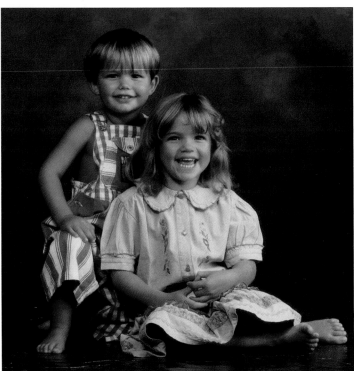

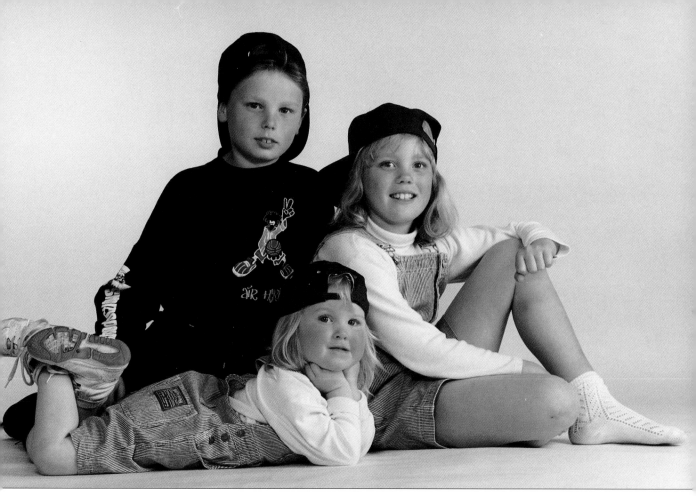

▲ How you position your subjects for a formal group portrait has a telling effect on the mood and character of the resulting photograph. By posing these children on the studio floor (taking the background paper right down and under the subjects) the photographer has immediately produced a relaxed and natural-looking portrait. Care has been taken to accommodate their widely differing heights so that the viewer's eye can take in all their faces in a series of comfortable 'steps' from one to the other.

PHOTOGRAPHER:
Llewellyn Robins

CAMERA:
6 x 4.5cm

LENS:
120mm

FILM SPEED:
ISO 50

EXPOSURE:
¹⁄₆₀ second at f11

LIGHTING:
**Studio flash x 2
(both fitted with softboxes)**

Hints and tips

● It is vitally important to adjust the height of your lighting heads to match the eyeline of your subjects.

● If the light source is too far above the eyeline, the noses of subjects will cast unattractive shadows down on to their faces.

● Special clamps and (for lightweight units) gaffer tape can be used to position lighting units exactly where you want them – especially useful when lighting stands can't be adjusted to suit.

◀ The triangular arrangement of these subjects produces a very stable and comfortable-looking composition. The long base of the triangle solidly plants the subjects on the studio floor.

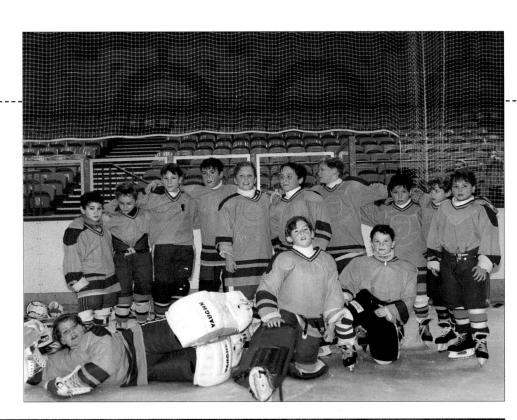

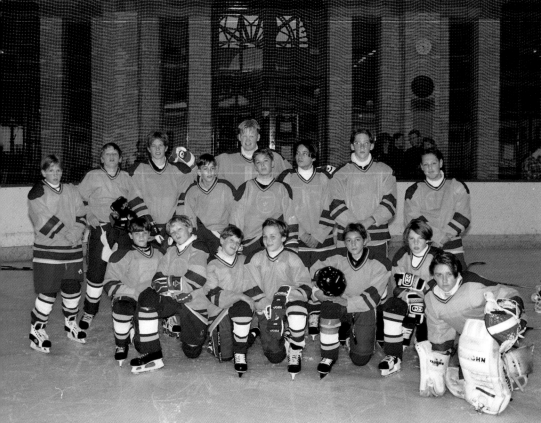

PHOTOGRAPHER:
Alan Harriman

CAMERA:
35mm

LENS:
28–70mm zoom

FILM SPEED:
ISO 64

EXPOSURE:
1⁄60 second at f4 and f11

LIGHTING:
**Accessory flash
and studio flash x 2**

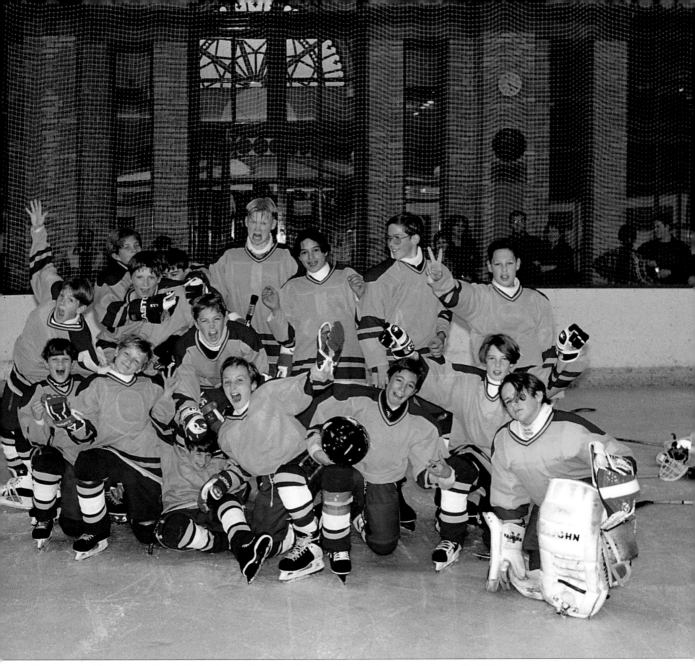

▲ There are many different approaches to a formal group portrait of, for example, an ice hockey team. Showing an appropriate setting is always worth while, since it gives the picture a proper context, but when this means that you have to light artificially a large, open space, problems can ensue. In the first version here (above left), the photographer used a high-output accessory flash, attached to a flash bar. This was enough to move the light source sufficiently from the lens axis to avoid red eye, but the open area of the ice rink was really too much for it, and flash fall-off is noticeable. In the next version (below left), two portable studio lighting heads were used, one positioned either side of the camera. Overall, lighting is much better than before, and colours are also more accurate and cleaner looking, but the poses of the boys are too rigid and their faces not expressive enough. In the final version (above), you can see the reward for the photographer's perseverance. The lighting remained the same as in the previous shot, but a joke from the photographer has really brought the boys alive. This picture is a good group portrait not only because it is a fun picture, but also because it has managed to record the camaraderie and team spirit that holds them all together.

INTRODUCING A SENSE OF SCALE

When you see a photograph of a child in isolation, it is sometimes difficult to make any judgement concerning his or her size. One way of showing the diminutive fragility of very young babies is to photograph them against something of known size. The most obvious way to introduce this sense of scale is to include an adult, or at least part of an adult, in the frame along with the young subject.

If you are working in a studio set-up, babies and children coming in to be photographed will always be accompanied by their parents or some other responsible adult with whom the children feel comfortable. If you are shooting in a client's home, then again there will be an adult present whose help you can enlist.

As well as introducing a sense of scale, having an adult in the frame solves another problem – very young babies cannot support themselves while sitting up and so require some form of support to keep them upright.

PHOTOGRAPHER:
Robin Dance

CAMERA:
35mm

LENS:
75mm

FILM SPEED:
ISO 125

EXPOSURE:
¹/₂₅ second at f8

LIGHTING:
Daylight only

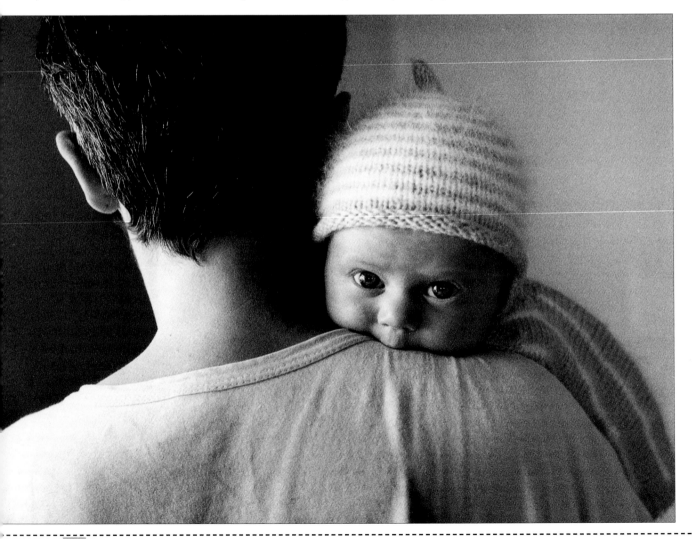

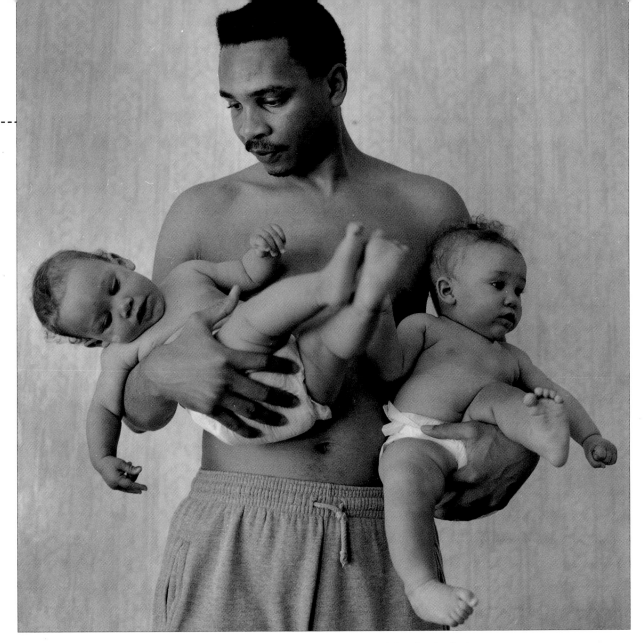

◀ While calming this baby during a break in an informal portrait session in the client's home, the father's entirely instinctive gesture – resting the baby against his chest so that his head was supported on his shoulder – was the inspiration for this shot. All the photographer then had to do was ask the father to turn around so that the child was looking directly at the camera.

▲ Seen here juggling two armfuls of restless energy is the babies' grown-up brother. Both children proved far too active and mobile to cooperate when placed on the studio floor, and so this solution elevated them to a comfortable shooting height and confined them in one place long enough to be photographed.

PHOTOGRAPHER:
Linda Sole

CAMERA:
6 x 4.5cm

LENS:
80mm

FILM SPEED:
ISO 200

EXPOSURE:
$\frac{1}{125}$ second at f8

LIGHTING:
Studio flash (fitted with softbox)

FILM GRAIN

The 'speed' of a film emulsion is related to the size of the grains of light-sensitive silver-halide material used to coat the plastic film base – 'slow' films (those with low ISO numbers) are coated with small grains, while 'fast' films (high ISO numbers) use larger clumps of silver halides. It is the increased surface area of the larger grains that makes them more light sensitive. Every doubling of ISO number is equivalent to an extra stop of exposure. For example, ISO 100 film is twice as sensitive as ISO 50 film, which means that you could use an aperture one stop smaller or a shutter speed one stop faster and still achieve the same overall film exposure.

However, the main point to bear in mind when selecting an appropriate film to use is that the faster the film the more obvious become the clumps of silver halides making up the emulsion when the original negative is printed or slide is projected. In most cases, you will probably want to use the finest grain of film that the lighting conditions will allow so that any graininess is absent completely or, at least, kept to a minimum. But there may be occasions when you want to emphasize film grain in order to make it an integral part of a picture's aesthetic appeal.

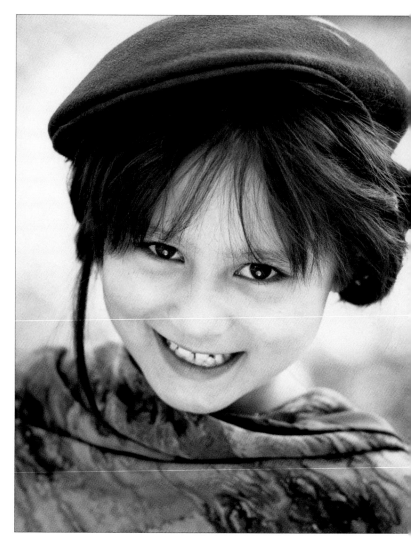

PHOTOGRAPHER:
Nigel Harper

CAMERA:
35mm

LENS:
105mm

FILM SPEED:
ISO 50

EXPOSURE:
¹⁄₁₂₅ second at f5.6

LIGHTING:
Daylight only

▲ ▶ *These two photographs, both shot on 35mm-format black and white film, demonstrate the grain responses of different emulsion speeds. The first (above) was taken using a slow, fine-grain film, which was given normal development, and the whole negative was enlarged. The other (right) was taken on a much faster film stock, given speed-enhanced development and only about two-thirds of the negative was enlarged.*

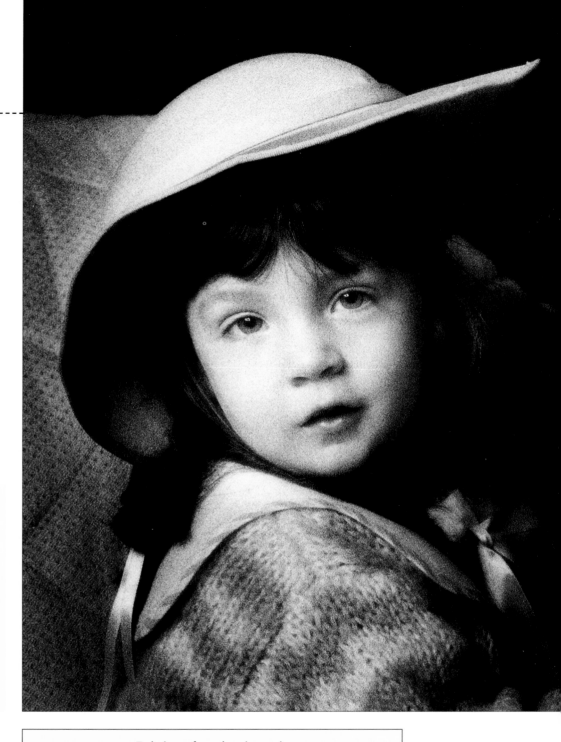

PHOTOGRAPHER:
Nigel Harper

CAMERA:
35mm

LENS:
50mm

FILM SPEED:
ISO 1600

EXPOSURE:
⅛ second at f8

LIGHTING:
Studio flash

Techniques for enhancing grain

Use the following simple methods if you want to increase the visual appearance of film grain in the final print.

● Use a high-speed film emulsion (ISO 800 or faster).

● Make larger-than-normal prints or enlarge just a small part of the original film negative.

● Underexpose the original film image and then increase film development time to compensate.

● Use especially formulated speed-enhancing film developers.

● Print a fine-grained original through a texture screen.

SHOOTING RATE

The costs of film and its associated processing and printing, although significant, are not major elements in terms of the bill the client has to pay for a set of studio photographs. Following on from this, it is best to shoot more photographs than you think you will need for a client presentation, and pick only the very best of them, rather than find yourself having to make the numbers up by including pictures you would, if you had others from which to choose, reject. For fixed-fee work, however, don't shoot so much film that you compromise your profit margins.

When working with very young babies, whose body movements, facial expressions, and mood changes are totally unpredictable, your shooting rate is likely to be higher than usual. If you can, therefore, it may be best to negotiate a fixed fee for your studio time and the final number of prints, but with the client picking up the bill for the film and processing costs.

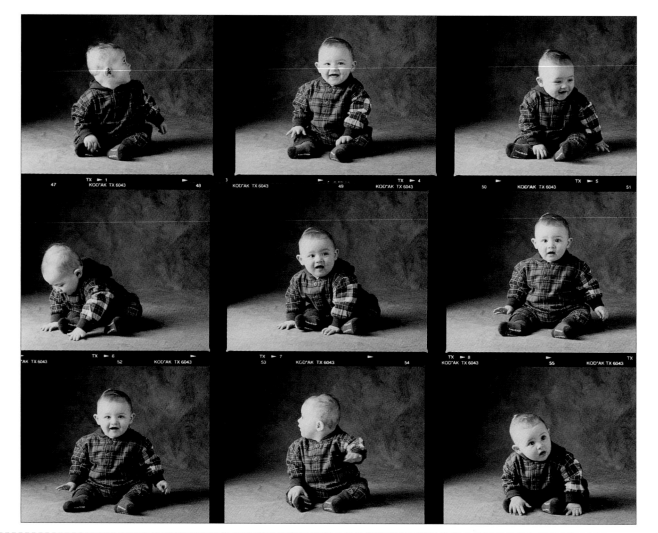

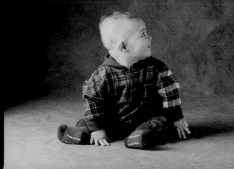
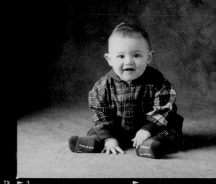

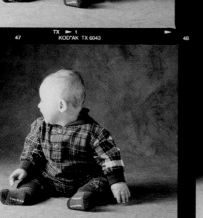
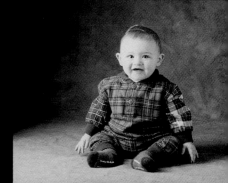

TX ► 1
47 KOD*AK TX 6043 48

TX ► 2
KOD*AK TX 6043 49 KOD*AK TX 6043

TX ► 3
50 KOD*AK TX 6043

TX ► 6
OD*AK TX 6043 52 KOD*AK TX 6043

TX ► 7
53 KOD*AK TX 6043 54

TX ► 8
KOD*AK TX 6043 55 KOD*AK TX

◄ ▲ *If shooting on negative film, the first stage of picture selection comes when you view a contact sheet of same-sized images (in other words, prints the same size as the negatives), or an enlarged contact sheet showing images usually twice the size of the negatives. For comfortable viewing, 35mm film needs a greater degree of enlargement at the contact print stage than the rollfilm formats, which produce larger negatives. All pictures are by Peter Millard.*

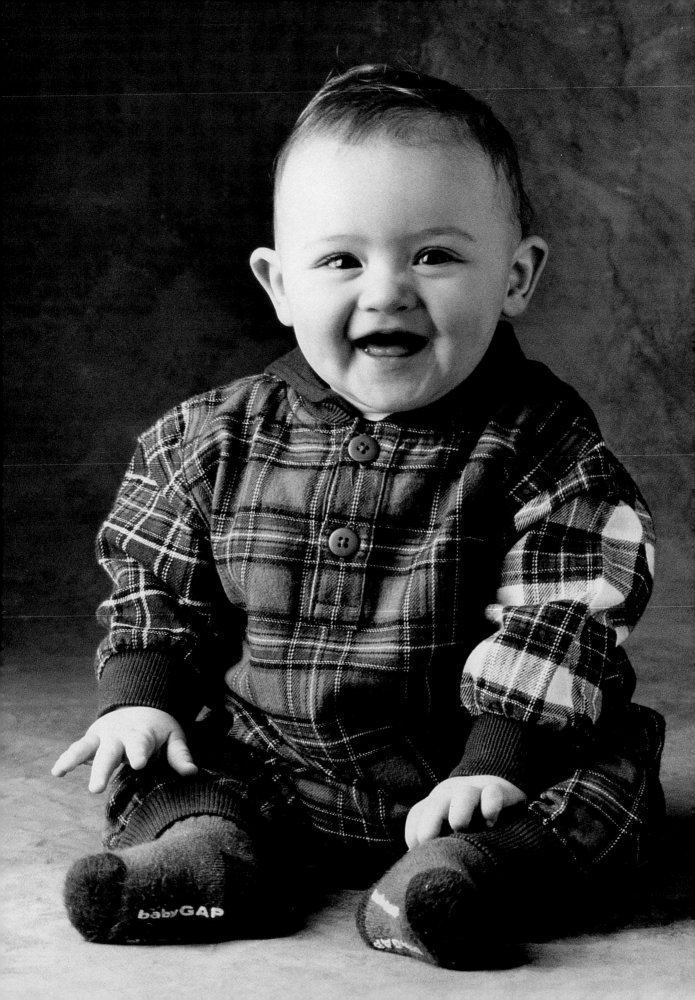

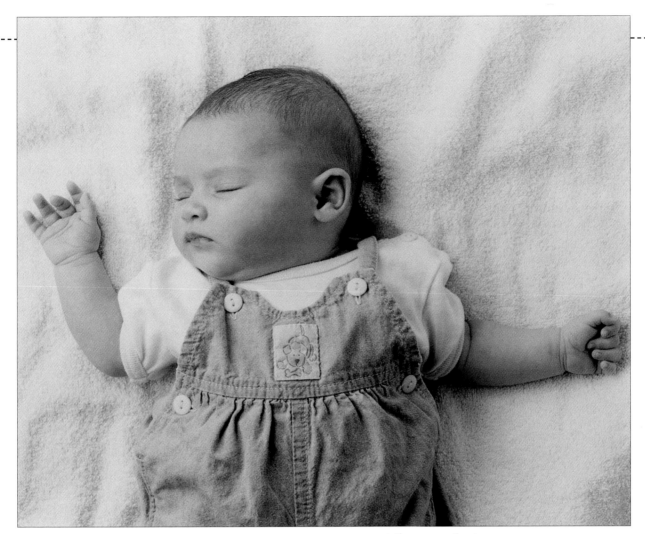

◄ By looking carefully at the images on the contact sheet (see previous pages), you can then make a decision about which ones to enlarge. Base your print selection on the subject's facial expression, image sharpness, the effects of light and shade, and the overall composition.

PHOTOGRAPHER:
Peter Millard

CAMERA:
35mm

LENS:
90mm

FILM SPEED:
ISO 400

EXPOSURE:
⅟₆₀ second at f11

LIGHTING:
Studio flash x 2 (both fitted with softboxes)

▲ There are exceptions to every rule. When your subject is peacefully and happily asleep, you can take your time with the framing and lighting and, therefore, shoot the minimum amount of film in the knowledge that your success rate ought to be very high.

PHOTOGRAPHER:
Peter Millard

CAMERA:
35mm

LENS:
50mm

FILM SPEED:
ISO 400

EXPOSURE:
⅟₆₀ second at f8

LIGHTING:
Studio flash (fitted with umbrella reflector)

2

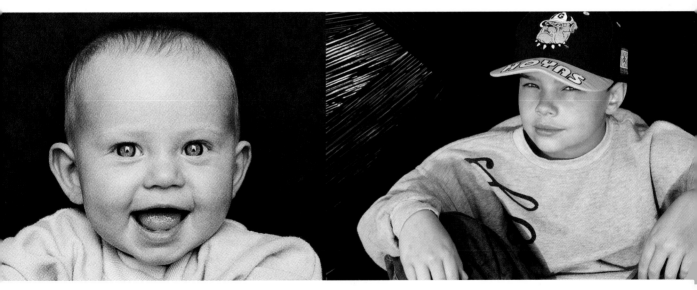

MOOD AND ATMOSPHERE

USING THE SETTING

Don't assume that there is only one approach to any photograph. If you have an attractive setting at your disposal, take the time to ensure that you get the very most out of it. Look for attractive ways to frame your subject – backgrounds and foregrounds that complement and harmonize with the child, for example, rather than compete for attention. Look for shooting angles that stress positive aspects of the setting while suppressing (or omitting) negative ones. And look at the fall of light and shade and decide how these lighting variations can be best used to your advantage.

Unless you are very experienced, it can be difficult to look at a general setting and see in your mind's eye just the portion of it that will be encompassed by the camera lens. It is all too easy to glance critically at a setting and decide it is unsuitable because you haven't isolated that one little corner that would be just perfect for your needs. This is where the camera's viewfinder is invaluable. Rather than looking at a scene with your unaided eyes, evaluate its potential by viewing it via the camera lens. Alternatively, hold your thumbs and forefingers at arms' length in front of you in the shape of a frame, similar to that of a viewfinder, and disregard any visual information coming to you from outside of the rectangle so formed.

PHOTOGRAPHER:
Llewellyn Robins

CAMERA:
35mm

LENS:
135mm

FILM SPEED:
ISO 64

EXPOSURE:
¹⁄₆₀ second at f11

LIGHTING:
Daylight only

▶ *Tall banks of foliage and pale-coloured flowers effectively enclose and isolate this part of the garden, transforming it into a secret and secluded space. The photographer has ensured that any foreground foliage is so close to the lens that the flowers and leaves are reduced to a soft and unobtrusive blur.*

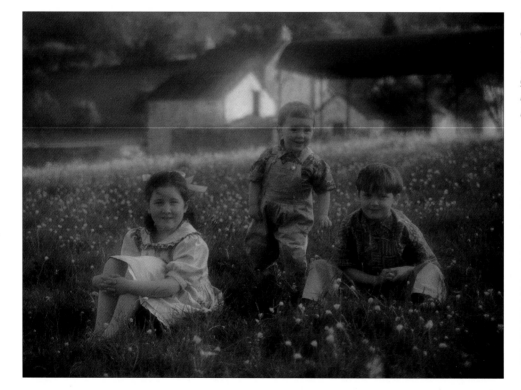

◀ *A broad and rolling sweep of flowering meadow with the family farmhouse tucked into the lee of a hill in the background provide the perfect bucolic setting for this charming children's portrait.*

PHOTOGRAPHER:
Ronald Turner

CAMERA:
35mm

LENS:
70mm

FILM SPEED:
ISO 50

EXPOSURE:
¹⁄₂₅₀ second at f8

LIGHTING:
Daylight only

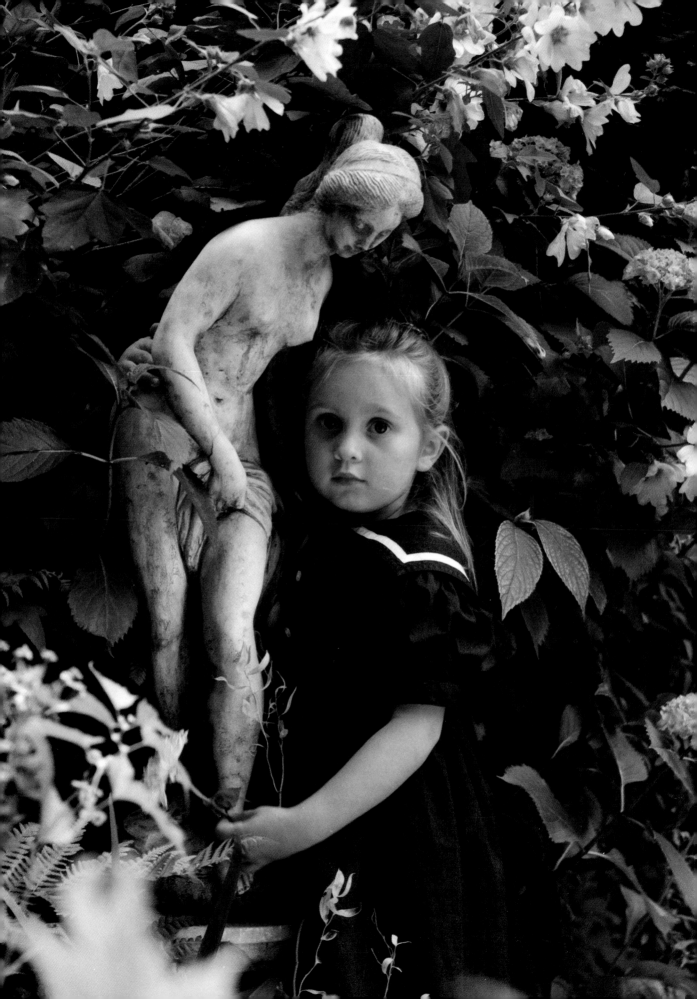

BABY FACE

As any portrait photographer will tell you, taking good pictures of young babies is notoriously difficult. The main difficulty lies in the fact that babies are too young to take any type of direction. This means that the onus is on you to be ready, camera poised and with lights set, for the right expression to emerge. Taking a more pro-active role, you will probably end up frantically gesticulating or making a series of coo-ing noises in an attempt to elicit an appropriate response from the young subject. And during all this, your concentration cannot waver for an instant and your eye cannot leave the viewfinder, for that hard-won expression will remain only fleetingly on your subject's face.

On the practical side, relying on studio or accessory flash can cause additional problems, since the intermittent bursts of intense light often startle or upset young children. Natural daylight or continuous-light tungsten lamps are often better alternatives.

PHOTOGRAPHER:
Robin Dance

CAMERA:
35mm

LENS:
90mm

FILM SPEED:
ISO 125

EXPOSURE:
¹⁄₁₂₅ second at f5.6

LIGHTING:
Daylight and tungsten floodlight (fitted with umbrella reflector)

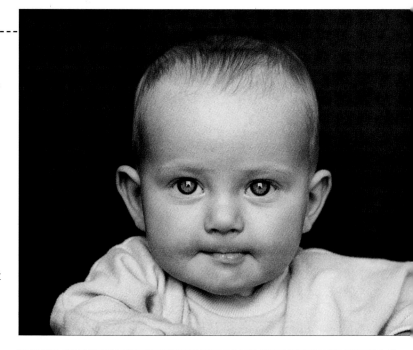

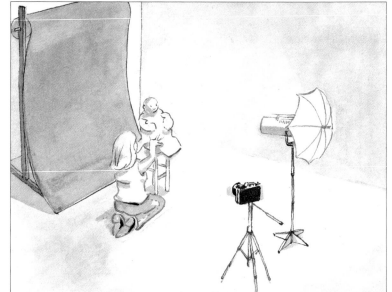

▲ The principal light used for this series of baby portraits was natural daylight from a high, tall window directly in front of the child. To supplement this, a tungsten floodlight positioned just to the right of the camera, and fitted with an umbrella reflector, bounced additional light on to the subject's face and shoulders. Dark-coloured background paper was far enough back from the subject to remain mainly completely unlit in the shadows.

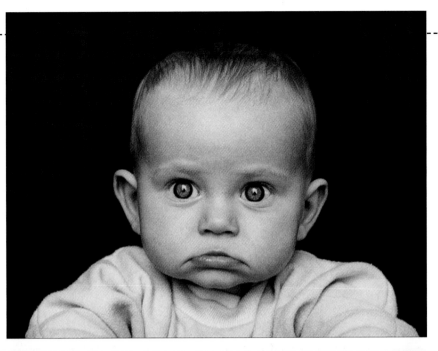

◀ ▼ ▶ *These photographs have captured three very different expressions, and they look best for being seen together. Natural daylight from a bright but sunless sky predominates (although some very soft, reflected artificial illumination was also used), and all pictures were taken within 30 seconds of each other. The lens, a moderate telephoto, had a sufficiently narrow angle of view to exclude the baby's mother, whose supporting hands are just out of shot.*

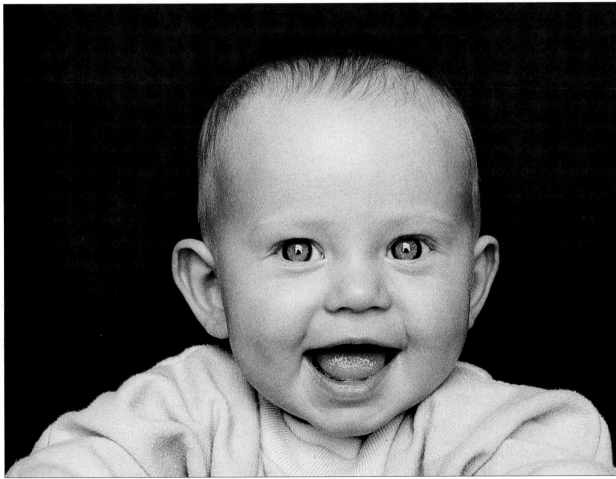

BRIDGING THE GENERATION GAP

Whenever you have a child, of any age, in the studio there should always be a responsible adult present – preferably the child's parent(s) or some other close member of the subject's family.

It is best to assume that in most cases children are likely to be unsettled by the strangeness of the studio environment, at least initially, and they will benefit from the reassurance a familiar and trusted person can give them. But rather than being merely a passive presence during the studio session, you can enlist the active cooperation of this person to encourage the child to respond in the way you want – perhaps by talking to the subject to get him or her to smile, look in a particular direction, turn slightly to help the fall of shadows and highlights, and so on.

PHOTOGRAPHER:
Anne Kumps

CAMERA:
35mm

LENS:
90mm

FILM SPEED:
ISO 200

EXPOSURE:
⅟₆₀ second at f16

LIGHTING:
Studio flash x 2 (both fitted with flash umbrellas)

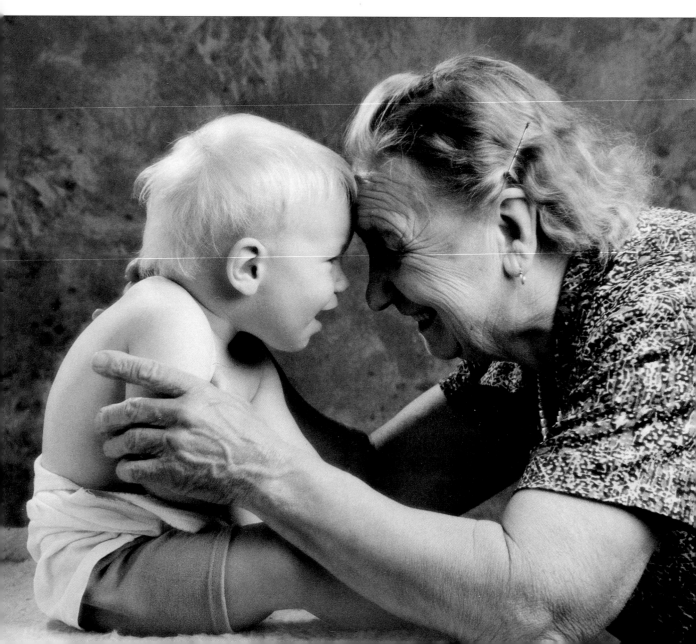

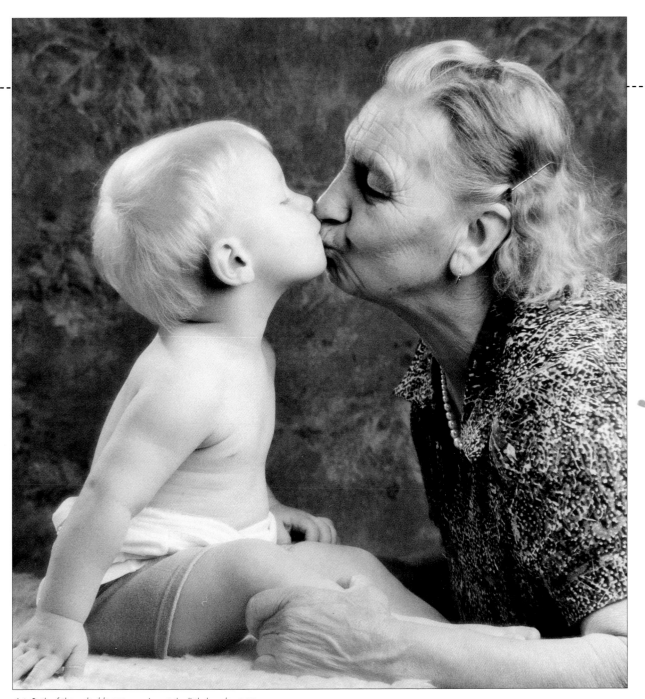

◀ ▲ *Both of these double por-*
traits illustrate just how
effectively the generation gap
can be bridged. As a first step,
the photographer had covered
a table top with a sheepskin
rug and set the lights in posi-
tion. She then called for her
young subject to be brought
on to the set by his grand-
mother, who had accompanied
him to the studio that day. As
she set the little boy down on
the rug, her natural instinct
was to reassure him by placing
her forehead against his and
then giving him a kiss before
withdrawing out of range of
the camera. The photographer,
seeing this simple act of close-
ness between the two through
the camera's viewfinder, fired
off two quick frames in as
many seconds.

MOOD AND CONTRAST

You can dramatically influence the mood of a portrait by manipulating the contrast of the final print. Print contrast is the exposure difference between the brightest highlights and the deepest shadows displayed by the image. You will often read advice, especially in relation to portraiture, implying that extreme contrast is something to be avoided – for example, fill-in lights are often employed to make exposure more equal across the entire image, or reflectors will be strategically positioned to bounce light into the shadows and so lighten them a little. However, with the right subject there is no reason why you should not exploit extreme contrast to create a more moody, compelling image, one that demands the viewer's attention.

High-contrast images such as those you can see here, are largely the result of using very localized light sources, so that only specific parts of the subject are lit while everything else remains unlit. Then, if you want to ensure that no unwanted tone starts to appear, the resulting negative can be printed on a hard grade of printing paper, which is designed to eliminate some or all of the intermediate shades of grey. Different grades of printing papers – usually from 1 (which gives a very soft result) to 6 (which gives a very hard result) – are only available for black and white, however, so if you are working in colour you must ensure that absolutely no light reaches those parts of the subject, or set, that you want swallowed up in darkness.

Hints and tips

● Use a hard-grade of printing paper with either a soft-contrast negative, in order to inject contrast into what would otherwise be a flat-looking print, or with a contrasty negative, in order to make a more dramatic statement.

● Use a soft-grade printing paper with a contrasty negative when you want to minimize the difference between highlights and shadows or when you want a print that is full of rich mid-tone detail.

● Manufacturers of black and white paper use different grade notation. Some use 0 to 5, while others use 1 to 6. Multigrade papers are also available, whose contrast response is governed by filters held under the enlarger lens.

PHOTOGRAPHER:
Nigel Harper

CAMERA:
35mm

LENS:
90mm

FILM SPEED:
ISO 25

EXPOSURE:
⅟₆₀ second at f8

LIGHTING:
Studio flash (fitted with snoot)

▶ A high-contrast image such as this usually works best with older children, when their faces have taken on more of a mature look. This subject's dark eyes and strong bone structure are, however, perfect for this technique. In order to increase the picture's dramatic content, parts of the image surrounding the face were dodged during printing.

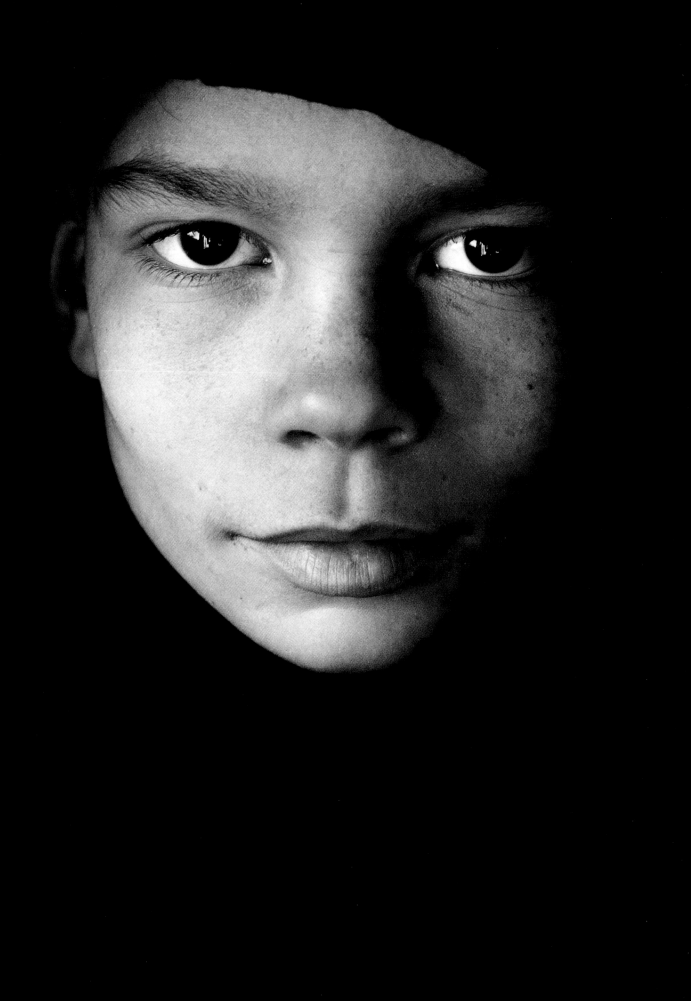

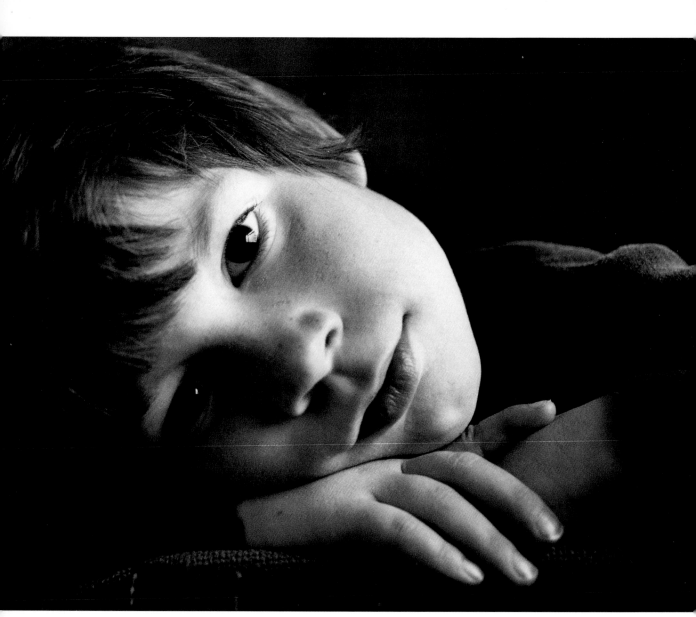

▲ *Though not as stark as the image on the previous page, this high-contrast result still has the effect of grabbing and then holding your attention. Exploiting contrast in this way is very effective when used occasionally. Like any other photographic technique, if it is used too frequently its impact will be diminished.*

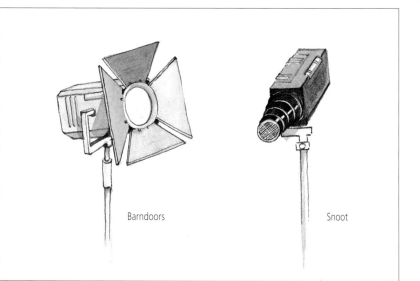

Barndoors

Snoot

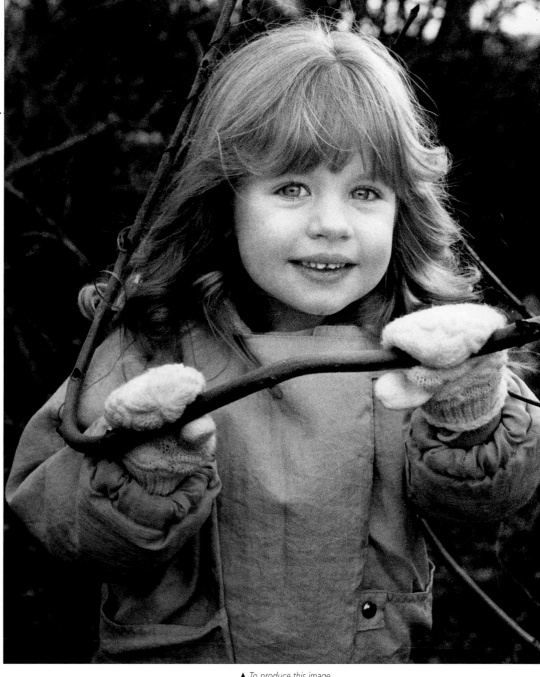

PHOTOGRAPHER:
Nigel Harper

CAMERA:
35mm

LENS:
135mm

FILM SPEED:
ISO 25

EXPOSURE:
⅟₆₀ second at f11

LIGHTING:
**Studio flash
(fitted with barndoors)**

▲ To produce this image, which is rich in mid-tone detail (the shades of grey between stark black and pure white) a normal-contrast negative was printed on a slightly soft (grade 2) printing paper.

PHOTOGRAPHER:
Nigel Harper

CAMERA:
35mm

LENS:
135mm

FILM SPEED:
ISO 200

EXPOSURE:
⅟₁₂₅ second at f5.6

LIGHTING:
Daylight only

◀ You can control the spread of light from your lighting units by using devices such as barndoors, which have movable flaps, or a snoot, to ensure that light reaches only those parts of the subject where it is required.

Working with Window Light

Window light can be a mixed blessing for the photographer. Large windows facing on to a bright but sunless sky, for example, are capable of producing a wide range of flexible, easily recorded lighting moods and atmospheres. Windows orientated so that they transmit bright and direct sunlight, however, can represent more of a challenge, since they often bring with them an excessive degree of contrast. In extreme cases, contrast can be so intense that highlights and shadows cannot both be accommodated by a single exposure setting.

But there really are no rules in photography to do with good and bad lighting, no 'rights' or 'wrongs', and if imaginatively conceived virtually any type of lighting effect can be turned to your advantage.

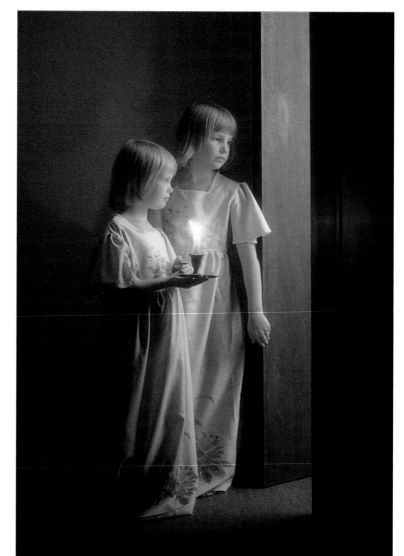

PHOTOGRAPHER:
Ronald Turner

CAMERA:
35mm

LENS:
28mm

FILM SPEED:
ISO 100

EXPOSURE:
⅙₀ second at f4

LIGHTING:
Daylight and candlelight

▲ The principal illumination for this double portrait came from a series of large windows opposite the doorway within which the two girls have been posed. The mood of the light – warm-coloured, late-afternoon sunlight – has been further enhanced by the candle the shorter of the two girls is carrying. Although its illumination is in no way strong enough to influence exposure to any degree, its coloration shows up as being distinctly warm-orange on the daylight-balanced film that was used to take this photograph.

▶ Large windows looking on to a sun-filled sky are often considered unsuitable for photography. Certainly, the lighting quality will be markedly different from that transmitted by windows receiving only indirect sunlight, but as you can see from this image, if used imaginatively virtually any type of lighting can be turned to good pictorial advantage. Here, extremely bright, direct sunlight, slightly diffused by net curtains, is flooding through full-length picture windows. The two figures closest to the glass appear to have been virtually 'dissolved' by the intensity of the light, while the foreground figure, although slightly over-exposed, looks transfixed by the light, caught perfectly in a typical dancer's pose.

PHOTOGRAPHER:
Ronald Turner

CAMERA:
35mm

LENS:
80mm

FILM SPEED:
ISO 100

EXPOSURE:
1/1000 second at f8

LIGHTING:
Daylight only

▲ Soft daylight from a slightly overcast, sunless sky was used as the sole illumination for this shot – ideal for the delicate complexion of a young baby. To ensure a soft, general light with just the right amount of contrast between shadows and highlights, the window light was further diffused by translucent curtains.

PHOTOGRAPHER:
Ronald Turner

CAMERA:
35mm

LENS:
90mm

FILM SPEED:
ISO 100

EXPOSURE:
$\frac{1}{125}$ second at f5.6

LIGHTING:
Daylight only

▶ This shot illustrates the point that you don't need expensive studio space and lighting equipment to produce first-rate pictures. Lighting, as you can see from the full-frame image (below left) is window illumination coming from the side, filtered and diffused by fine net curtains. The backdrop is simply a large piece of lace tacked to the wall and the picture, once cropped tighter on the subject (right), could not be bettered.

PHOTOGRAPHER:
Ronald Turner

CAMERA:
35mm

LENS:
50mm

FILM SPEED:
ISO 100

EXPOSURE:
$\frac{1}{125}$ second at f2.8

LIGHTING:
Daylight only

*A*DVERSE WEATHER

When the sky is heavy with the threat of rain or the air damp with mist or fog and light levels are poor and quickly deteriorating, most photographers put their camera away or confine their activities to indoor and studio work. Sometimes, however, it is just these types of 'poor' photographic conditions that can help to create eye-catching and unusual pictures.

High-speed film and modern fast lenses allow you to work in all but the dimmest conditions. If it is actually raining, however, you will have to take some precautions to protect your equipment – a plastic bag with a hole cut to let the lens poke through should be enough. If the plastic is flimsy, you will still be able to feel and operate all the camera and lens controls.

PHOTOGRAPHER:
Tim Ridley
CAMERA:
6 x 4.5cm
LENS:
150mm
FILM SPEED:
ISO 800
EXPOSURE:
⅟₃₀ second at f8
LIGHTING:
Daylight only

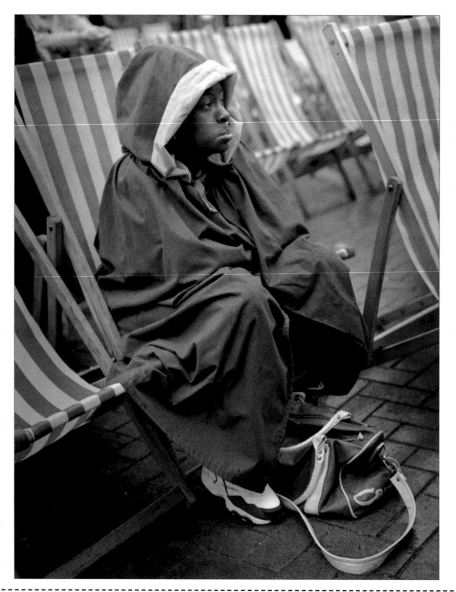

◄ *On a rainy afternoon in a resort town on the coast of England, any prospects of good photography seemed remote – that is, until the photographer's eye fell on this dispirited-looking boy gazing forlornly towards the rapidly shrinking horizon. What struck the photographer most, apart from the boy's wonderful expression, was the unintentional humour of the situation – sitting on a deck chair shrouded from head to toe in a raincoat and hood.*

PHOTOGRAPHER:
Linda Sole
CAMERA:
35mm
LENS:
80mm
FILM SPEED:
ISO 400
EXPOSURE:
⅟₃₀ second at f4
LIGHTING:
Daylight only

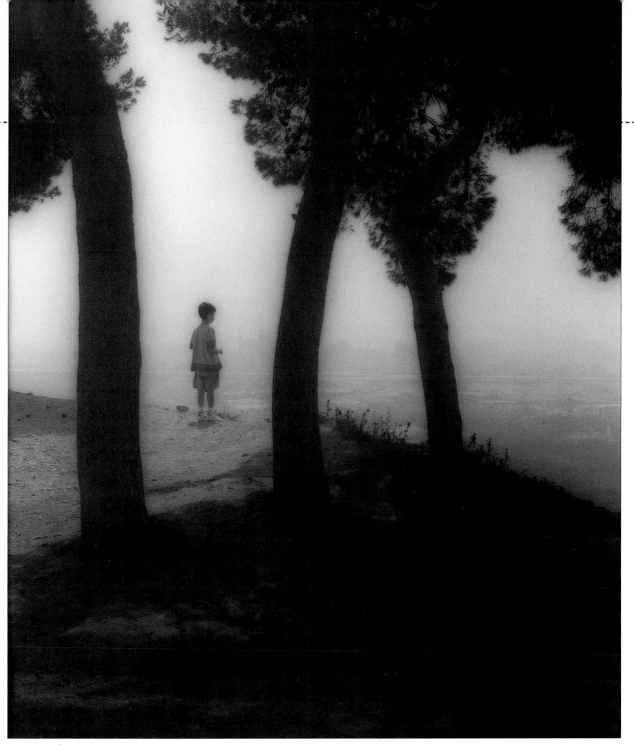

▲ This beautifully conceived and executed image could not have been planned in advance. The weather conditions were so poor on this day that it seemed almost pointless to take the camera out. But old habits die hard the photogra- pher gratefully realized as he lifted his camera, took a general light reading, adjusted his position slightly to frame the boy between the tree trunks, and carefully squeezed the shutter release to avoid jarring the camera.

Some potential metering problems

In some types of adverse weather, judging or metering exposure can be a problem. In fog or mist, for example, the moisture particles suspended in the air tend to bounce light around, creating the impression that there is more light illuminating your subject than is, in fact, the case.

If subject exposure is more critical than an overall exposure allows for, take a close-up spot reading from the most important subject colour or tone. If you don't want to (or can't) approach your subject, take a general light reading and then open up one or two stops to avoid underexposure.

USING DEPTH OF FIELD

Depth of field – the area of acceptably sharp focus both in front of and behind the point the lens is focused on – varies according to the aperture you select, the focal length of the lens used, and the distance of the subject from the camera. Depending on the effect you want to achieve, you can show the surroundings to your subject in a variety of different ways – ranging from a soft blur to pin-sharp and full of critical detail.

The more detail that can be discerned in the surroundings the more carefully you need to compose your shot so that the principal subject is still apparent. Sometimes you will want the foreground or background to remain neutral, providing, say, a simple setting that in no way competes for attention. At other times, however, the surroundings may be an important part of the story your picture is telling, giving the subject or subjects a proper context.

PHOTOGRAPHER:
Majken Kruse

CAMERA:
35mm

LENS:
135mm

FILM SPEED:
ISO 200

EXPOSURE:
⅛₂₅ second at f4

LIGHTING:
Daylight only

◀ ▲ *The plain-green grassy background to the outdoor portrait (left) was adding nothing important to the overall composition and so the photographer decided to utilize depth of field to show it as nothing more than a colourful blur. Note that in the next shot (above), although the photographer used the same lens and exposure settings, and approximately the same focusing distance, the subject and background are so close together that depth of field renders both with the same clarity.*

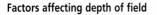

Factors affecting depth of field

Depth of field varies according to:

● The aperture set on the lens – the smaller the aperture the greater the depth of field.

● The focal length of the lens – the shorter the focal length the greater the depth of field at any given aperture.

● Subject distance from the camera – the further the subject is from the camera (in other words, the greater the focusing distance) the greater the depth of field for any given focal length or aperture setting.

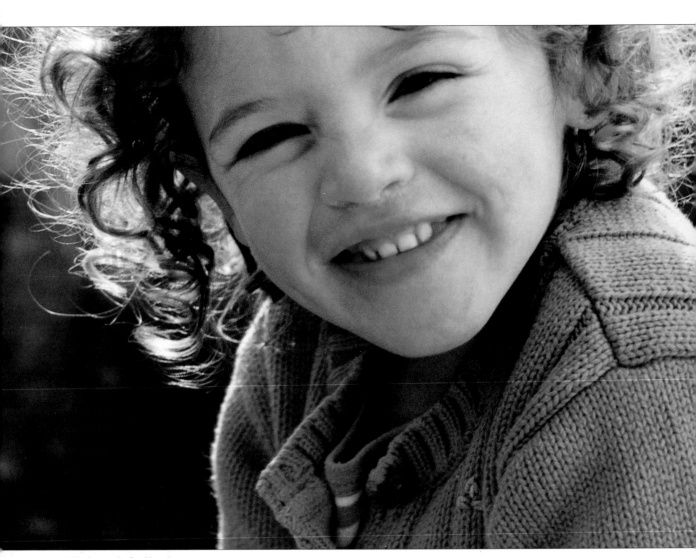

▲ *The longer the focal length of the lens and the wider the aperture, the shallower the depth of field. In order to isolate the subject of this portrait from her surroundings, the photographer opened up the lens to its maximum aperture, first ensuring that the subject and background were well separated.*

PHOTOGRAPHER:
Peter Millard

CAMERA:
6 x 4.5cm

LENS:
180mm

FILM SPEED:
ISO 50

EXPOSURE:
½₅₀ second at f5.6

LIGHTING:
Daylight only

PHOTOGRAPHER:
Linda Sole

CAMERA:
6 x 6cm

LENS:
80mm

FILM SPEED:
ISO 125

EXPOSURE:
½₂₅ second at f4

LIGHTING:
Daylight only

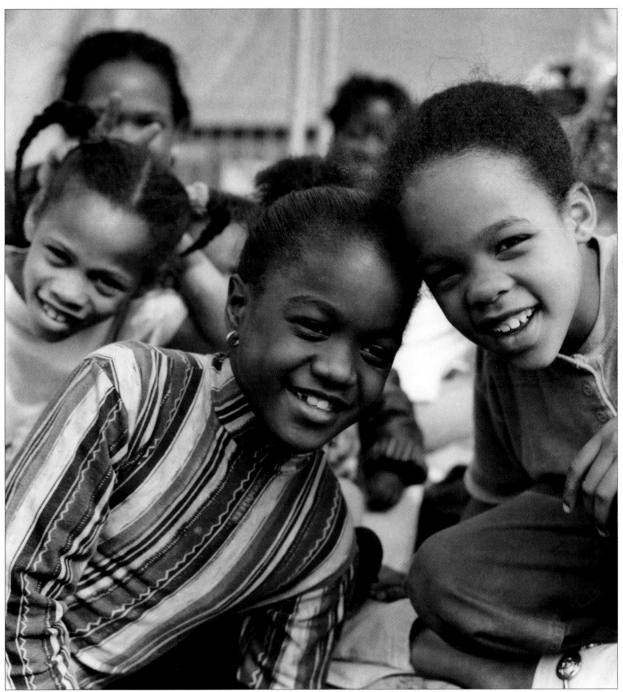

▲ In this informal outdoor portrait, the photographer used depth of field to strike a balance between clearly distinguishing the principal subjects from their background and showing enough of their surroundings (and in sufficient clarity) to provide additional interest and a proper context.

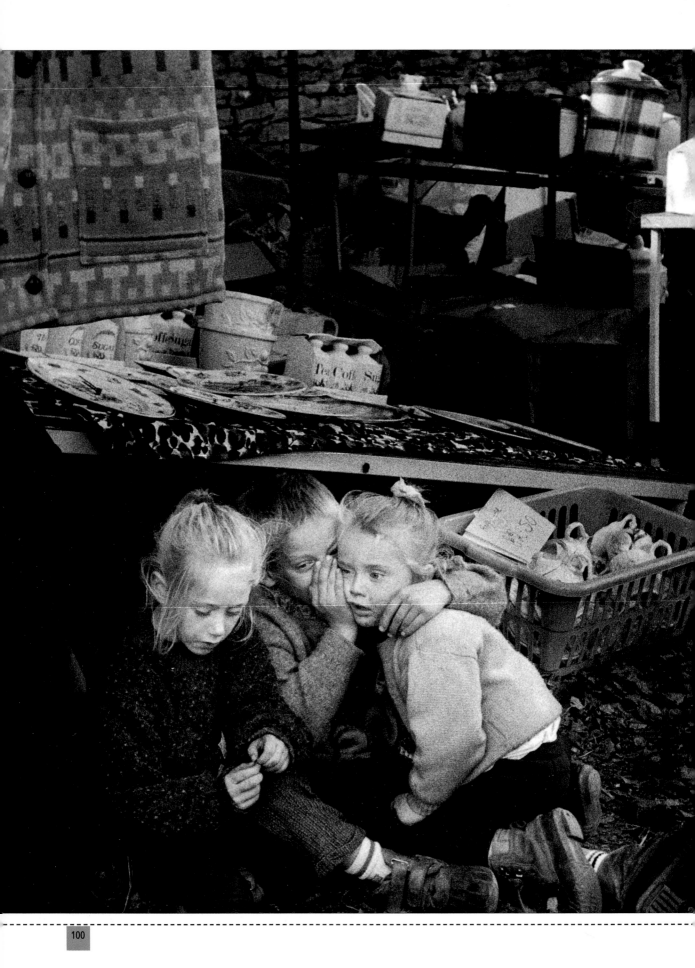

PHOTOGRAPHER:
Linda Sole
CAMERA:
35mm
LENS:
35mm
FILM SPEED:
ISO 400
EXPOSURE:
½₂₅₀ second at f11
LIGHTING:
Daylight only

◄ *A moderate wide-angle lens coupled with a small lens aperture has rendered this evocative street market scene sharp right from the immediate foreground, through the middle distance, and almost to the far background.*

Neutral density filtration

The need to achieve a very limited depth of field can sometimes result in an impossible exposure setting. For example, to knock a background completely out of focus you may have to select your widest possible aperture – say, f1.2. In a brightly lit scene, this may mean compensating for exposure by setting a shutter speed of, say, ½₂₀₀₀ second, or even faster. If your camera offers a fastest shutter speed of only ½₁₀₀₀ second, the resulting picture will be one stop overexposed. To overcome this problem you can use a neutral density lens filter to cut down the amount of light entering the lens. Neutral density filters (available in different strengths) are suitable for use with black and white film and, because they affect all wavelengths of light equally, colour film. Choose the strength of filtration required in order to achieve correct exposure.

FLASH AND DAYLIGHT

Most often, flash is used outdoors on location when natural light levels are low overall and a general increase in illumination is required. Bear in mind that the effective range of flash is greatly diminished outdoors because, unlike shooting indoors, there are no surfaces such as walls and ceilings to confine and reflect the light back on to the subject.

However, flash can be used more subtly to create a range of different lighting moods, even on bright days when you would think that there was plenty of natural daylight. For example,

strong, very directional sunlight can be awkward to shoot in – the brightly lit surfaces of anything directly facing the sun tend to contrast too intensely with any adjacent shaded surfaces. In such a situation as this, flash can be used to direct extra light into the shadows in order to bring them up to a level where they can be comfortably accommodated by an exposure calculated for the highlights. Flash can, likewise, be used when you want to retain the soft, moody atmosphere of backlighting but don't want to produce a silhouette of your shadowy subject.

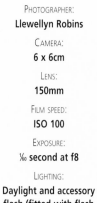

PHOTOGRAPHER:
Llewellyn Robins

CAMERA:
6 x 6cm

LENS:
150mm

FILM SPEED:
ISO 100

EXPOSURE:
⅙₀ second at f8

LIGHTING:
Daylight and accessory flash (fitted with flash umbrella)

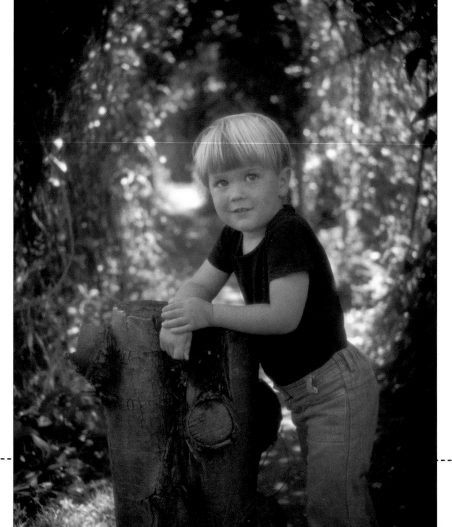

◀ The only natural light in this shot was coming from behind the subject, and an overall light reading would have resulted in the boy being reduced to a near-featureless silhouette. It was the tunnel-like woodland growth and the soft-filtered daylight that had attracted the photographer to this setting, and so the problem became how to retain the mood and quality of the light while producing a well-lit portrait of the subject. The solution was to bounce light from an accessory flashgun fitted with a flash umbrella, so that the softness of the natural daylight was matched by that of the flash.

◀ *Standing on a shaded woodland-type path adjacent to a large park lit by an open sky, these girls required an exposure setting very different to the brighter area beyond. A reading taken for the girls alone indicated settings of f4 at ⅟₆₀ second, while a reading from the park was f11 at ⅟₁₂₅ second. Directing a hand-held flashgun at the subjects, set to three-quarter power and with its head muffled with a layer of thin, white cloth to diffuse the light, the photographer set a compromise exposure, which, although overexposing the background a little, still retained enough detail to give the subjects a sense of setting.*

PHOTOGRAPHER:
Llewellyn Robins

CAMERA:
35mm

LENS:
105mm

FILM SPEED:
ISO 50

EXPOSURE:
⅟₁₂₅ second at f5.6

LIGHTING:
Daylight and diffused accessory flash

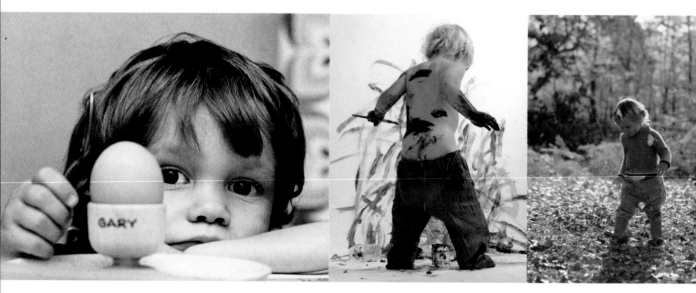

3

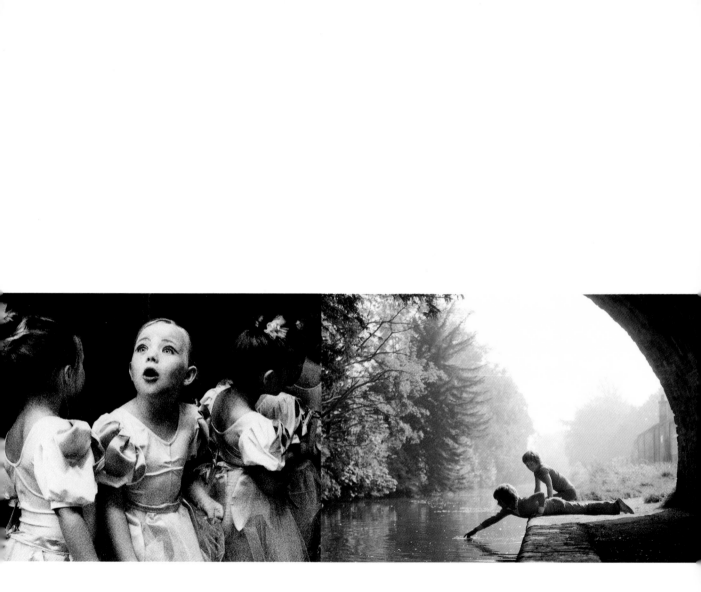

CANDID APPROACH

PICKING YOUR MOMENT

Successful candid photography relies on you being in the right place at the right time, ready with your camera to pick off shots as any opportunities present themselves. For candid work, even if the subjects are aware of your presence, a moderate telephoto lens is best. For the 35mm format, choose a lens in the range of 100mm to 200mm. A camera fitted with a lens somewhere in this range of focal lengths should be light enough for you to hand hold without an undue risk of camera movement – assuming that you select a reasonably fast shutter speed and your body is comfortably braced.

Rather than using a telephoto of a fixed focal length, a telephoto zoom may be a more flexible option. A zoom of about 80–210mm will give you an excellent choice of subject framings, showing varying degrees of peripheral detail without you having to change your shooting position – remember, the more you move about the more attention you will draw to yourself. Then, pick your moment carefully and when you see exactly the image you want in the viewfinder, squeeze off a shot. If time allows, zoom in or out to give a variation in subject framing and expose another frame as a back-up.

▶ *Foreground interest can be as important to the making of a good photograph as an appropriate background. In this shot, the reed bed in front of the boys had enough presence to break up what would have been a large area of flat, blue-coloured sky, gave cover to the photographer, and was not so dense that it obscured the subjects.*

Shooting with long lenses

● Stand with your legs comfortably apart and with your feet firmly planted on the ground.

● Support the camera body with one hand, where your finger can reach the shutter release.

● Support the lens with your other hand, where your fingers can operate the focus control and aperture ring (if not fully automatic).

● Tuck your elbows comfortably in to the sides of your body.

● Bring firm and steady pressure to the shutter release – don't stab down on it, since this may jar the camera.

PHOTOGRAPHER:
Tim Ridley

CAMERA:
35mm

LENS:
70–210mm (set at 135mm)

FILM SPEED:
ISO 200

EXPOSURE:
$\frac{1}{125}$ second at f11

LIGHTING:
Daylight only

PHOTOGRAPHER:
Tim Ridley

CAMERA:
35mm

LENS:
70–210mm (set at 80mm)

FILM SPEED:
ISO 200

EXPOSURE:
¹⁄₁₂₅ second at f8

LIGHTING:
Daylight only

▲ *Once children are engrossed in each other's company, even if they are aware that you are there with a camera, they soon tend to ignore you in favour of their own interests and activities. This beach scene is particularly appealing because of the backlighting, which has created a halo of highlights defining the boys' bodies.*

PHOTOGRAPHER:
Tim Ridley

CAMERA:
35mm

LENS:
70–210mm (set at 80mm)

FILM SPEED:
ISO 200

EXPOSURE:
⅟₃₀ second at f16

LIGHTING:
Daylight only

▲ *There are no unbreakable rules in photography. Although the object usually is to produce a sharp and clear image of the subject, here the photographer has panned the camera vertically while shooting at a slow shutter speed. The result shows enough blur to imply action while not disguising the boy's identity.*

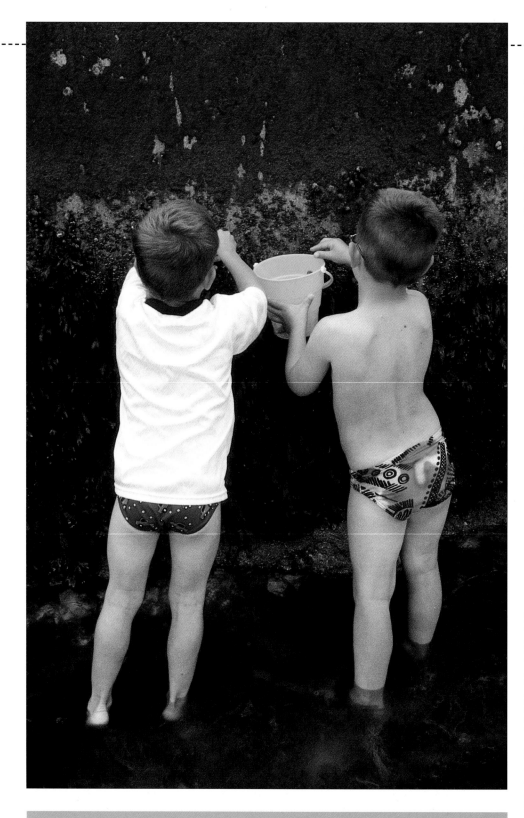

◄ *Strong contrasts between dark and light shades and colours within a photograph help to bring it alive, creating a strong three-dimensional quality. Note here how the boy's white T-shirt seems to glow out of the frame when seen against the dark green of the algae-covered sea wall.*

PHOTOGRAPHER:
Tim Ridley

CAMERA:
35mm

LENS:
70–210mm (set at 185mm)

FILM SPEED:
ISO 200

EXPOSURE:
½₅₀ second at f5.6

LIGHTING:
Daylight only

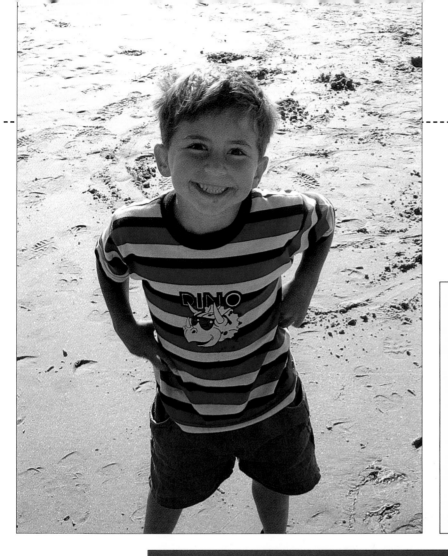

Subject eyeline

These two pictures by Tim Ridley demonstrate the importance of shooting from approximately the subject's eyeline. In the first shot (left), the photographer was standing looking down on the boy. As a result, he looks diminished in stature and the perspective is not at all natural. In the next picture (below), the photographer has crouched down so that he was shooting from just below the boy's eyeline. Although this is only a head-and-shoulders shot, the child has far more presence in the frame and it makes a more pleasing composition.

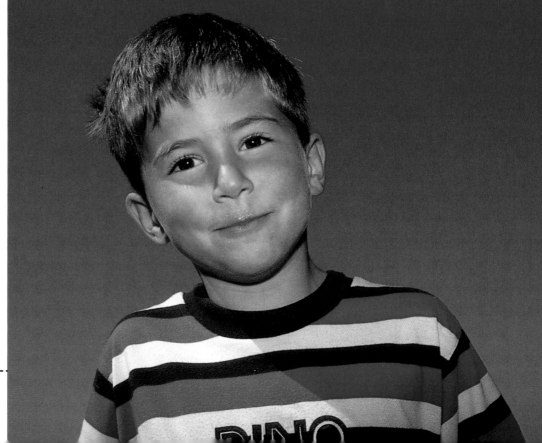

▼ *For candid work, the further back you can keep from your subjects the better your chances of remaining unobserved and not influencing their reactions. Fascinated by the community of aquatic wildlife on the steps and supports down below at the end of this jetty, the photographer's stealth was probably not necessary to take this unselfconscious portrait.*

PHOTOGRAPHER:
Tim Ridley

CAMERA:
35mm

‹ LENS:
70–210mm (set at 210mm)

FILM SPEED:
ISO 200

EXPOSURE:
½₅₀ second at f11

LIGHTING:
Daylight only

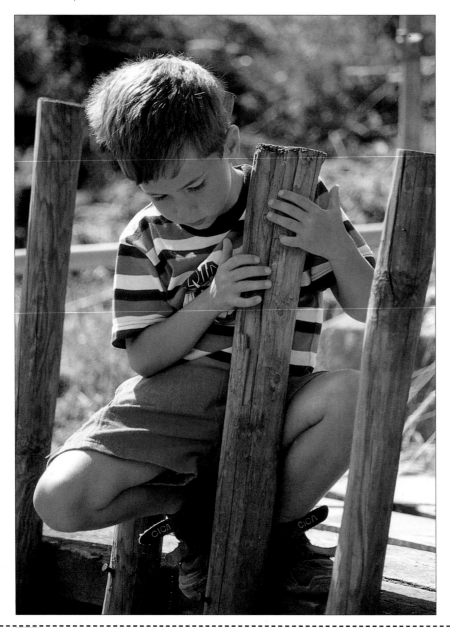

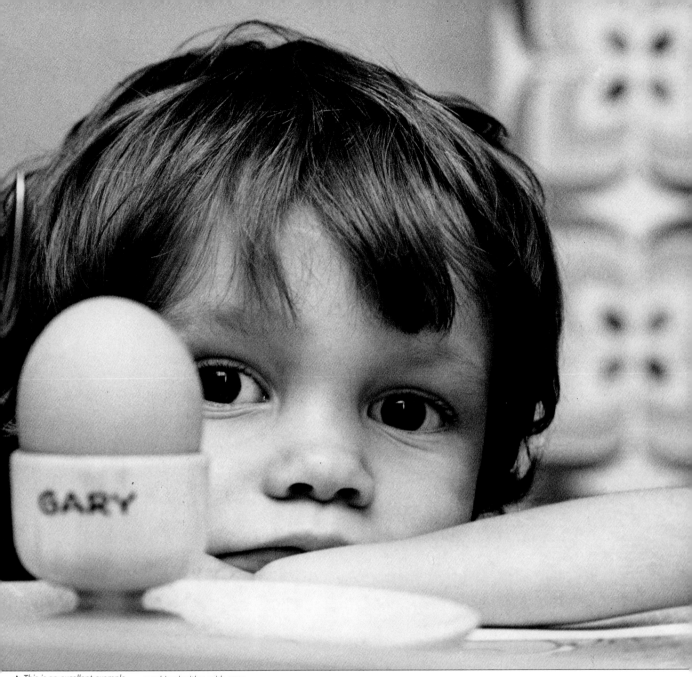

▲ This is an excellent example of the photographer picking the right time and judging the moment of exposure to perfection. The position of the child's face in relation to the eggcup is just right, as is his expression and his hand poised to bring the spoon down on top of the shell. The telephoto lens used to take this photograph, combined with a wide aperture to compensate for the poor indoor lighting, resulted in a very shallow depth of field. In situations such as this, it is nearly always best to focus carefully on the subject's eyes – if they are pin-sharp the picture has a good chance of working even if everything else is soft and blurred.

PHOTOGRAPHER:
Nigel Harper

CAMERA:
35mm

LENS:
250mm

FILM SPEED:
ISO 400

EXPOSURE:
⅟₆₀ second at f4.5

LIGHTING:
Daylight only

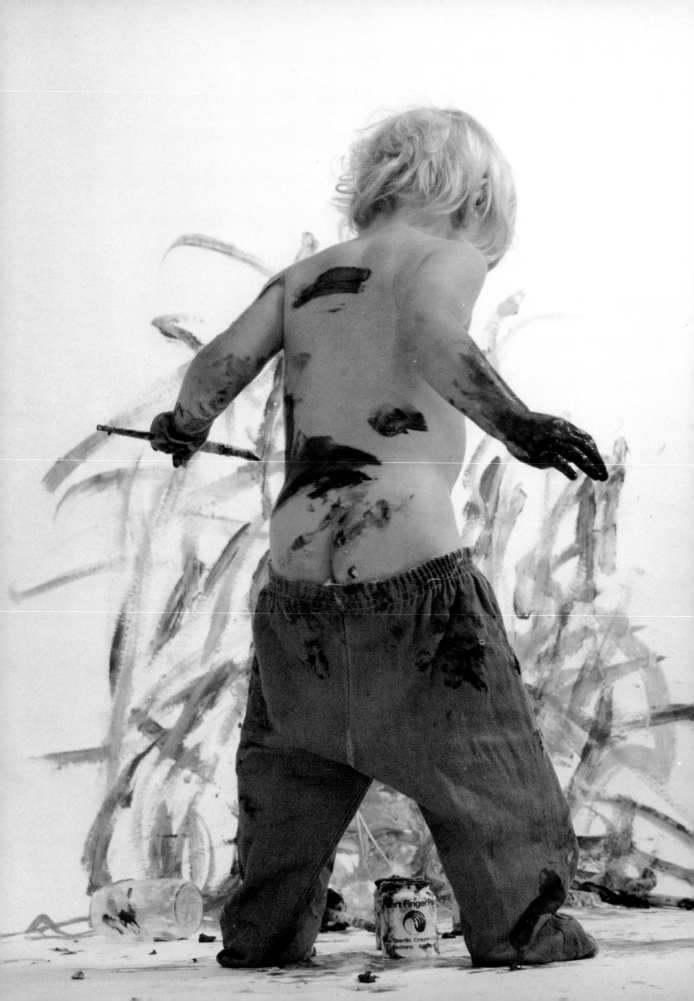

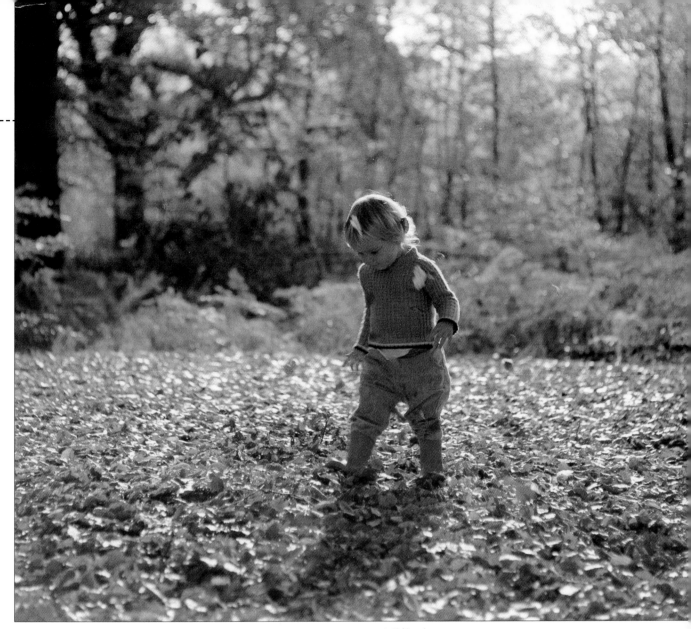

◀ Candid photography is possible in the studio, as this shot of a budding abstract artist demonstrates. Caught in a perfect pose, looking for all the world as if he is poised for another burst of maniacal activity with his paintbrush, the photographer had no opportunity to adjust the lighting and so used the single studio flash unit that was already set up. Luckily, this flash unit was fitted with a flash umbrella, so the light reaching the subject is soft and diffused.

PHOTOGRAPHER:
Llewellyn Robins

CAMERA:
6 x 4.5cm

LENS:
180mm

FILM SPEED:
ISO 100

EXPOSURE:
⅟₆₀ second at f8

LIGHTING:
Studio flash (fitted with flash umbrella)

▲ Picking the moment to shoot is often critical to the success of a picture. In this fall scene, the photographer held back from shooting, waiting for the child to kick sufficient leaves up into the air for them to make an attractive contribution to the composition. Although the subject is backlit, the sunshine was very 'watery' and so no exposure allowance was necessary.

PHOTOGRAPHER:
Llewellyn Robins

CAMERA:
35mm

LENS:
70–210mm (set at 150mm)

FILM SPEED:
ISO 100

EXPOSURE:
⅟₆₀ second at f5.6

LIGHTING:
Daylight only

NATURAL DISTRACTIONS

In the studio, or more formal indoor and outdoor photographic sessions, the short attention span of children can be a problem, especially if you want your subjects in a particular position or adopting a specific pose or expression. For candid photography, however, this same factor can work in your favour. As soon as children see a camera, a not uncommon reaction is a scramble for centre stage. When this happens, the best advice is to play along with this outburst of enthusiasm. Take a few shots, even if you don't think they will be usable. After a few minutes, most children will happily become distracted by other interests, leaving you to get on with the real photography.

While shooting, keep as low a profile as you can. The less you intrude on your subjects' activities, the less they will be aware of you and the better your chances of taking a set of candid, natural-looking photographs. In this respect, a long lens is often better to use than a standard or wide-angle. For example, with a 135mm lens (on a 35mm camera) you can stand well back on the periphery and still fill the frame with a good-sized image.

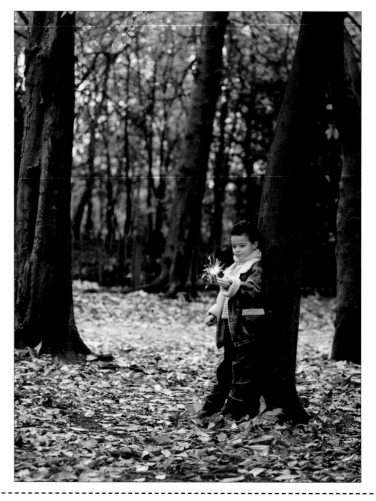

◀ Bright yet gentle fall sunshine, the russety colours of a carpet of leaf litter, and a young boy totally absorbed in the dancing light of a sparkler make a charming combination. Noticing the boy wandering away from his friends, the photographer readied herself for the picture, setting the exposure controls for where she thought the boy was heading. As soon as he settled himself against the tree she quickly raised the camera and took the shot.

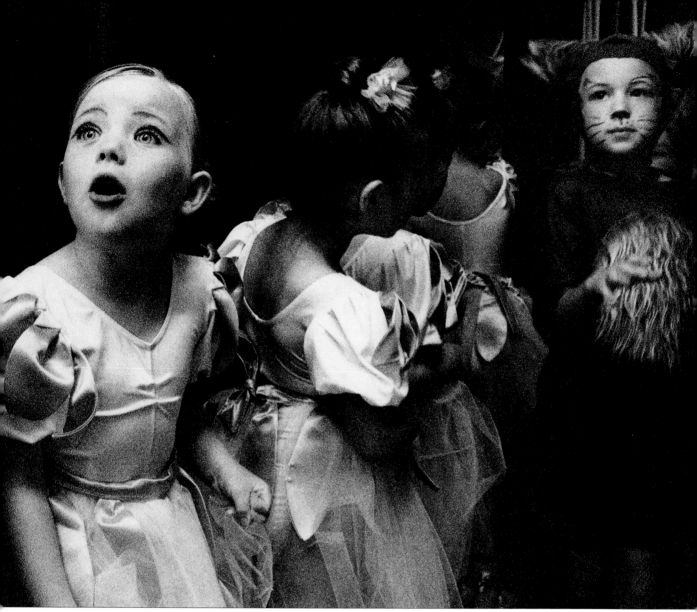

PHOTOGRAPHER:
Majken Kruse

CAMERA:
35mm

LENS:
135mm

FILM SPEED:
ISO 200

EXPOSURE:
¹⁄₂₅ second at f4

LIGHTING:
Daylight only

▲ *Waiting in the wings for their turn to come on stage, you can see the excitement in the bodies of this troop of young dancers, especially in the fisted hand of the girl who has suddenly spun around. Although the girls all knew that the photographer was covering the event, they had* become so accustomed to her presence during rehearsals that they had stopped really noticing her. And with the added distraction of the performance being so close, an excellent set of completely candid pictures were the result (see pp. 134–41).

PHOTOGRAPHER:
Linda Sole

CAMERA:
6 x 7cm

LENS:
120mm

FILM SPEED:
ISO 800

EXPOSURE:
¹⁄₆₀ second at f5.6

LIGHTING:
Daylight and diffused accessory flash

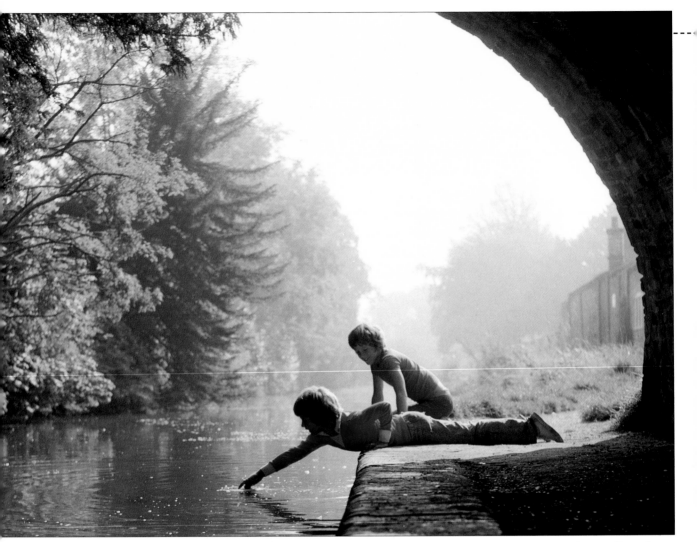

PHOTOGRAPHER:
Llewellyn Robins

CAMERA:
35mm

LENS:
70–210mm (set at 180mm)

FILM SPEED:
ISO 64

EXPOSURE:
¹⁄₆₀ second at f16

LIGHTING:
Daylight only

▲ *Water, whether still or moving, seems to cast a magical spell over children, drawing them like a magnet. Completely absorbed in something they have seen just beneath the surface of this quiet stretch of canal, these two brothers were unaware of the photographer as he paused briefly on the tow path to take their picture.*

PHOTOGRAPHER:
Llewellyn Robins

CAMERA:
35mm

LENS:
90mm

FILM SPEED:
ISO 64

EXPOSURE:
¹⁄₁₂₅ second at f5.6

LIGHTING:
Daylight only

▶ *When something really takes their interest, children can be uncharacteristically patient. These two rather despondent-looking fishermen had spent the best part of the afternoon with their home-made fishing rod trying unsuccessfully to catch a fish from this little foot bridge. So absorbed were they in this task that they took not the slightest notice as the photographer carefully lined up the shot, making sure that there was sufficient foliage around the edges to create an attractive frame for the composition.*

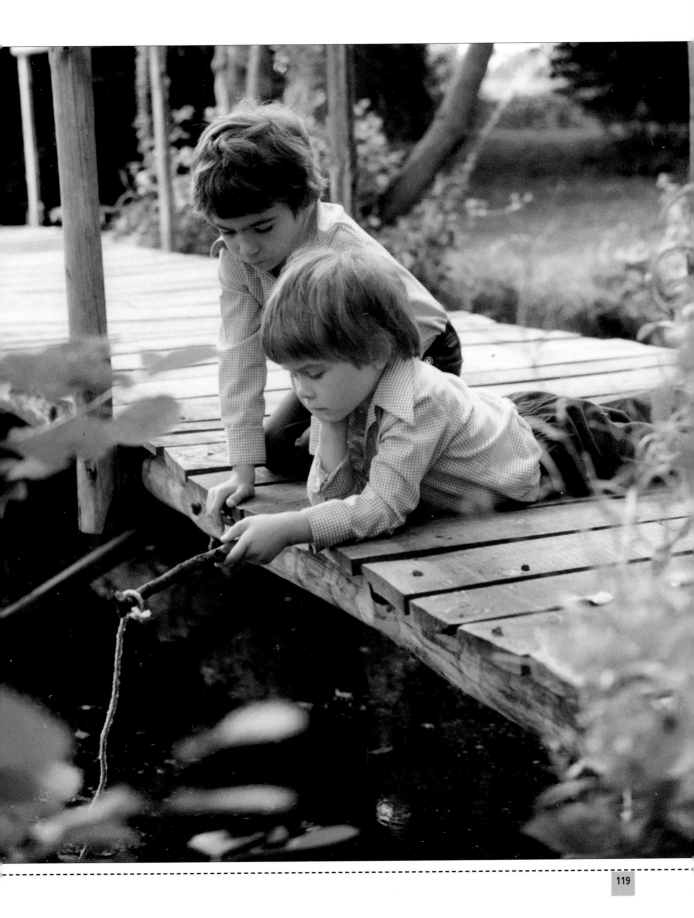

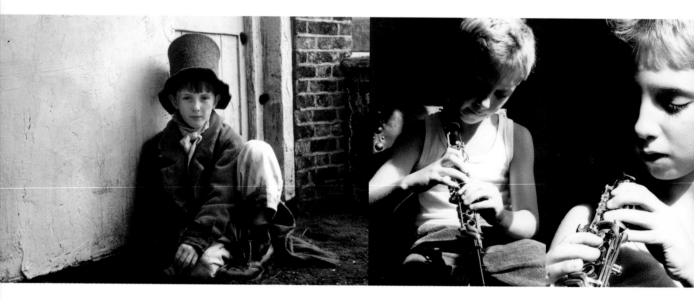

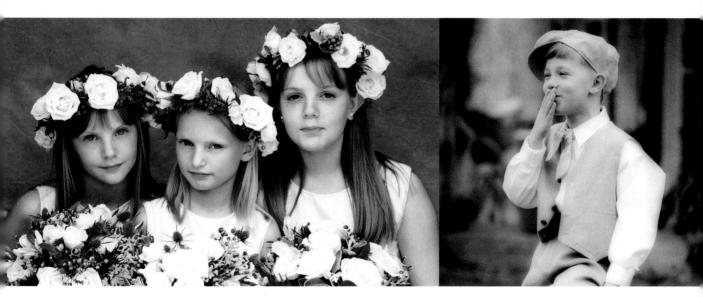

INTERESTS AND ACTIVITIES

DRESSING UP

Formal children's portraits – those posed specifically for the camera, most often in a studio but also in the client's home or outdoors – mostly show the subjects scrubbed clean and dressed for the part. Children of a certain age are usually so keen to dress up that many photographers keep a pile of fun clothing in their studios – and many excellent portraits have emerged from a child's own choice of bizarre attire.

Dressing up can have more significance than simple play, however. The film and television industries have a constant need for new young faces for plays, soaps, drama, film, and, of course, advertising. Children play parts spanning the centuries, from futuristic fantasy to the nostalgic days of bygone eras. For that handful of successful child actors, as well as the countless unlucky ones, one of the first steps along the road to discovery is to have a professional portfolio of character photographs taken that can be used to interest an agent, casting director, or art director.

▶ *Having overcome all of the initial hurdles, these two Dickensian street urchins have been fortunate to be cast in professional acting roles. They were photographed on the film set, already dressed up and waiting for their turn in front of the camera.*

PHOTOGRAPHER:
Majken Kruse

CAMERA:
6 x 4.5cm

LENS:
85mm

FILM SPEED:
ISO 50

EXPOSURE:
1⁄60 second at f22

LIGHTING:
Daylight and reflector

◀ *The danger when photographing children wearing hats is that their faces may become lost in the shadows. To overcome this, either use supplementary flash to brighten their faces or, as here, a reflector to bounce daylight precisely where it is needed.*

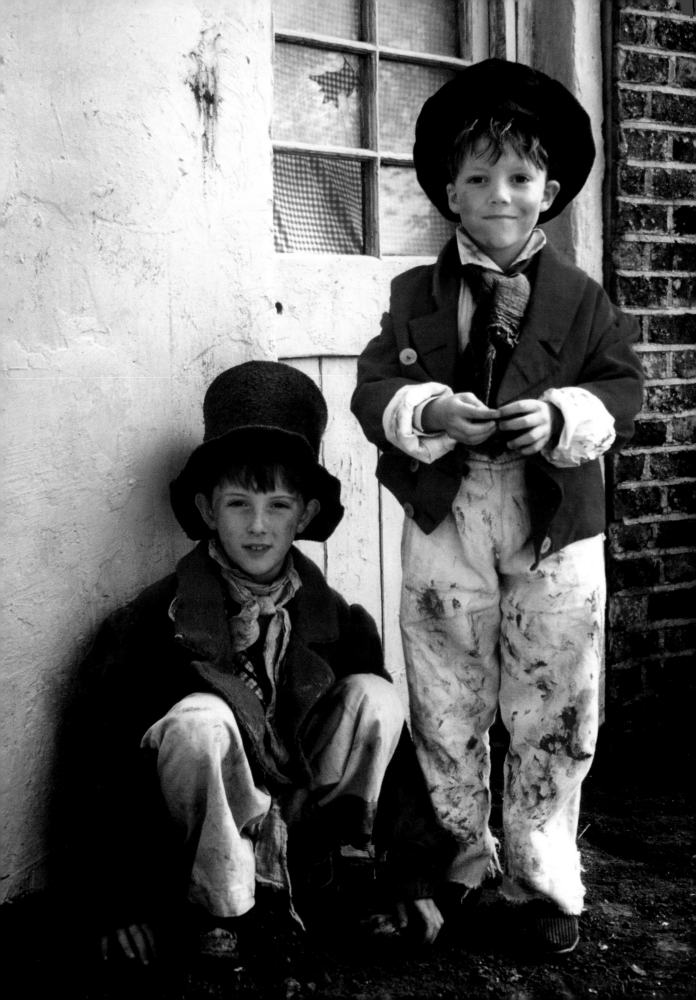

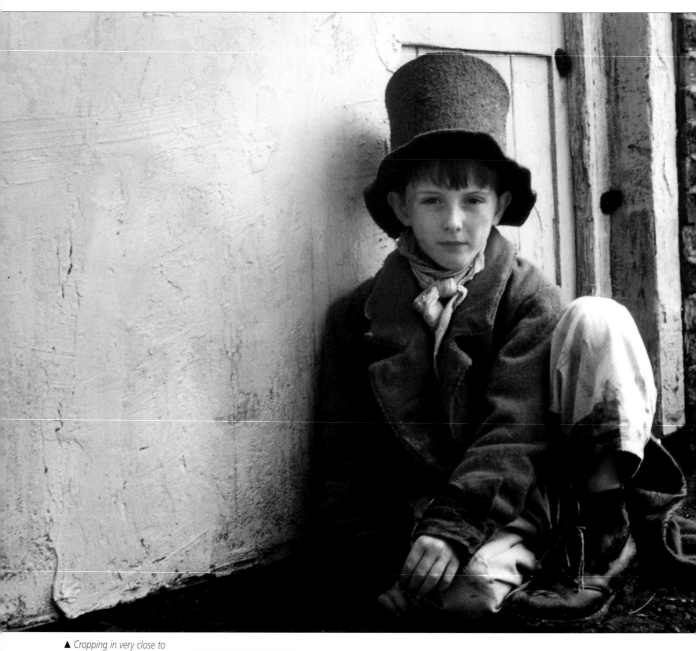

▲ *Cropping in very close to remove the foreground completely enhances the impact of the figure. This horizontal framing of the shot also helps to show parts of the setting that have visual interest, such as the rough-plastered walls. This helps add to the period feel of the photograph.*

PHOTOGRAPHER:
Majken Kruse

CAMERA:
6 x 4.5cm

LENS:
120mm

FILM SPEED:
ISO 50

EXPOSURE:
¹⁄₂₅ second at f22

LIGHTING:
Daylight and reflector

PHOTOGRAPHER:
Jos Sprangers

CAMERA:
35mm

LENS:
**70–210mm zoom
(set at 175mm)**

FILM SPEED:
ISO 125

EXPOSURE:
¹⁄₁₂₅ second at f4

LIGHTING:
Daylight only

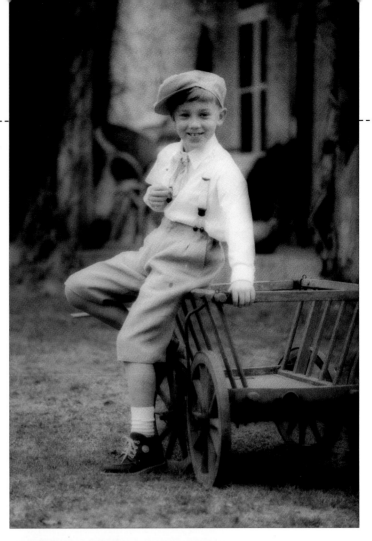

▶ *For the type of photograph seen here to work, the subject has to be able to handle the part with confidence and not appear to be embarrassed or awkward in any way. The outside set was carefully propped before shooting and the combination of a wide aperture (and, hence, limited depth of field) and a soft-focus filter imparts an atmosphere of 'old-world' charm.*

▶ *The advantage of using a zoom lens is that you can vary the framing and the size of the subject in the frame without having to change camera position. Also, any filters you use on a zoom apply to the entire zoom range, whereas lenses of different focal lengths often have different-sized mounting threads.*

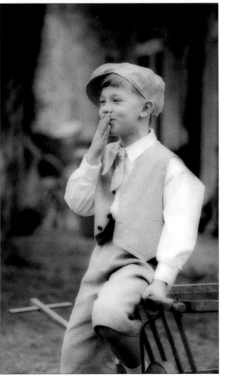

PHOTOGRAPHER:
Jos Sprangers

CAMERA:
35mm

LENS:
**70–210mm zoom
(set at 210mm)**

FILM SPEED:
ISO 125

EXPOSURE:
¹⁄₁₂₅ second at f4

LIGHTING:
Daylight only

YOUNG MUSICIAN

If your work is not to take on a rather mechanical feel – where technically there may be nothing wrong with it yet it somehow fails to get beneath the skin of the subject – you need to approach every commission with enthusiasm, curiosity, and a positive and an enquiring eye. It is difficult not to take along with you to any new job the preconceptions and approaches that have worked for you in the past. Indeed, this is what your experience is based upon. However, the danger is that you may become so dependent on applying the stock solutions of the past that you fail to recognize the fresh opportunities and approaches offered by the current subject and situation.

In the informal series of photographs reproduced on these four pages, you can see how a small detail became the anchor around which the entire session developed. The pictures were all taken in the young clarinetist's home where the photographer was taken with the rather old-fashioned appearance of the vest the boy was wearing. This immediately suggested a photographic approach to her. By positioning an armchair for the subject to sit on against a plain wall near a window bright with afternoon sunlight, and ensuring that her cropping allowed nothing to enter the frame of an obviously contemporary nature, she has managed to convey a simple, timeless quality, reinforced to great effect by applying sepia toner to the final results.

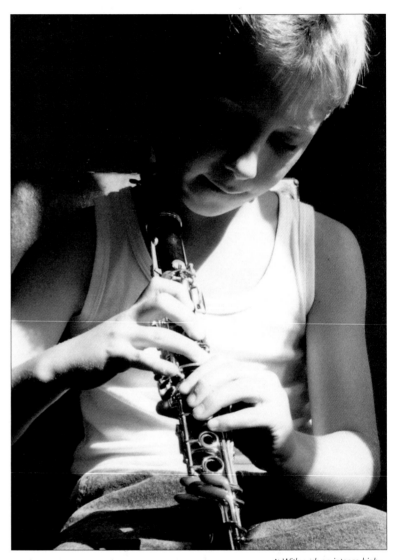

▲ With such an intense highlight in the centre of the frame, underexposure of the more shadowy parts of the subject and the background was inevitable without compensation. However, the photographer opted to let the shadows look after themselves and has allowed the highlight to dominate exposure.

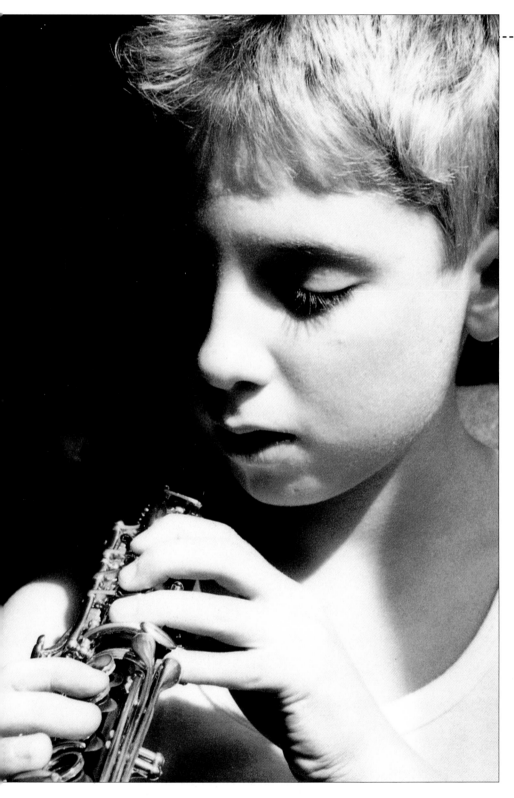

◄ *The aperture and shutter speed settings used in this shot are the same as those used in the first, and the pictures were taken only seconds apart. But simply by reorienting her position just slightly, the photographer has increased the contrast between the lit and unlit halves of the young musician's face.*

PHOTOGRAPHER:
Juliet Greene

CAMERA:
6 x 4.5cm

LENS:
105mm

FILM SPEED:
ISO 400

EXPOSURE:
½₅₀ second at f16

LIGHTING:
Daylight only

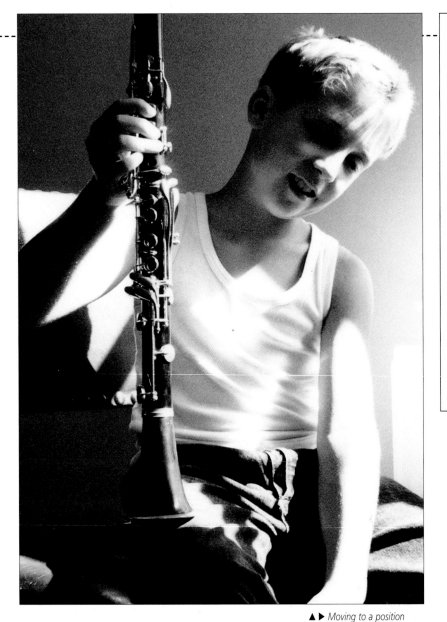

SEPIA TONING

Sepia toning black and white prints is not difficult. Special solutions can be bought at any large photographic store, or you can mix your own chemicals to make up the necessary bleaching agent and toner.

Bleaching agent
Potassium ferricyanide 50g
Potassium bromide 50g

Dissolve in water to make up 500ml of solution and dilute 1:9 before using
Toner
Sodium sulphide 25g

Dissolve in water to make up 500ml of solution

Warning!
You need to take particular care when mixing and using chemicals of any description, but especially acids. Wear rubber gloves and eye protectors when handling all bleaching and toning chemicals and solutions, even if diluted.

▲ ▶ *Moving to a position more adjacent to the window and shooting with the light, the background wall is now similarly lit to the subject and so appears more obvious. It was particularly important that nothing could be seen that set the subject in a specific time period and thus spoiled the nostalgic quality of the scene.*

PHOTOGRAPHER:
Juliet Greene

CAMERA:
6 x 4.5cm

LENS:
80mm

FILM SPEED:
ISO 400

EXPOSURE:
½₅₀ second at f11

LIGHTING:
Daylight only

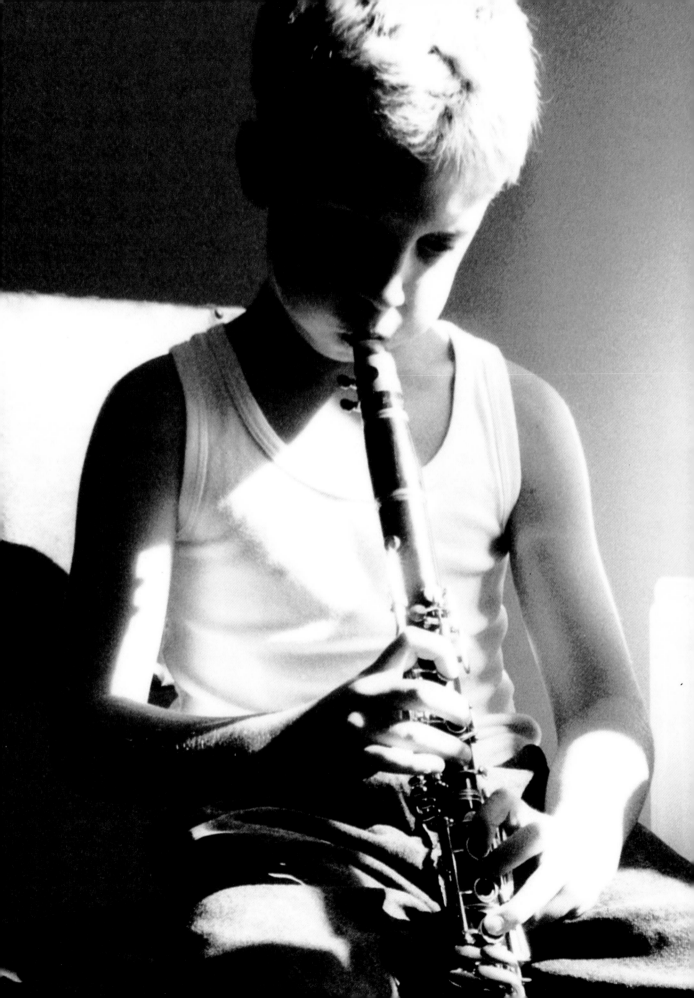

WEDDING PORTRAITS

Children are often an integral part of wedding ceremonies, especially formal affairs with flower girls, bridesmaids, page boys, and so on.

Portraits of the participants taken on the day of the actual wedding tend to be rather hurried affairs. Although photographers usually work from a pre-agreed shot list, time pressures are always great, and the weather often cannot be relied on for natural light work outdoors. Because of this, it is increasingly common for the main members of the bridal party to visit the photographer's studio immediately before or just after the wedding day to sit for a series of more formal portraits. These, when combined with the pictures from the 'big day', make for a well-rounded portfolio.

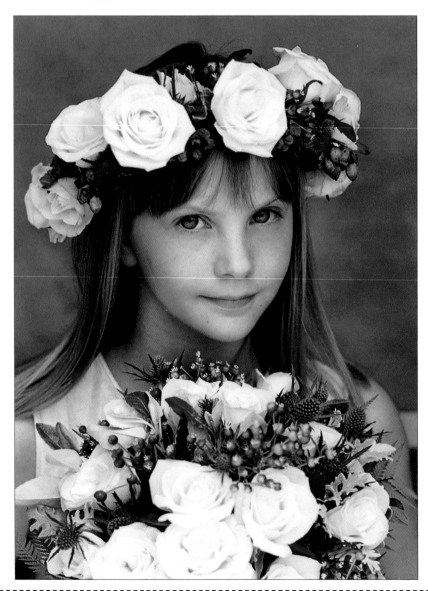

◀ ▲ As well as group shots of the main participants (above), such as the bridesmaids, make sure to take individual portraits (left) of any of the children who are close relatives of the bride or groom. These will always be particularly desirable from the clients' point of view. Also, make an effort to take shots of any young family members who may live a long way away and are, therefore, not often seen by the rest of the family.

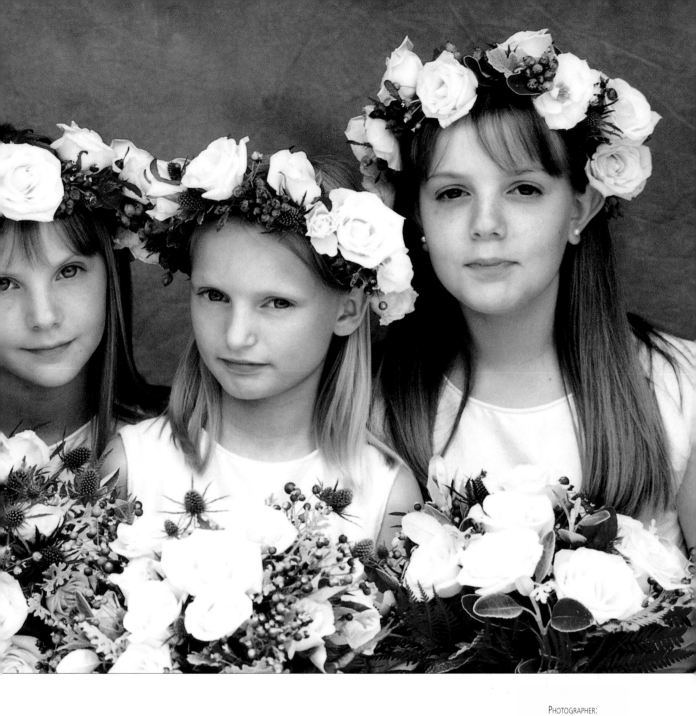

PHOTOGRAPHER:
Majken Kruse

CAMERA:
6 x 4.5cm

LENS:
85mm and 180mm

FILM SPEED:
ISO 50

EXPOSURE:
⅟₆₀ second at f11

LIGHTING:
Studio flash x 2

5

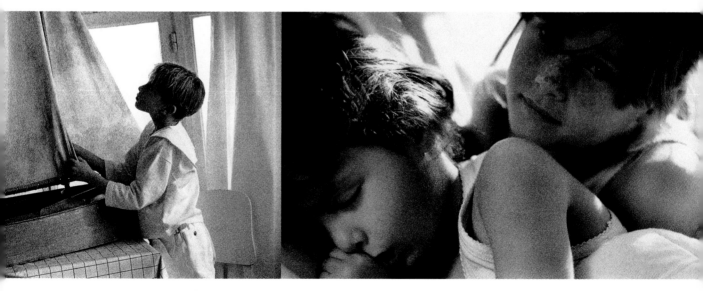

PORTFOLIOS

LINDA SOLE

If you have a particular interest in one area of children's activities you may be able to turn it into a portfolio-building, as well as a money-earning, photographic opportunity. In the selection of photographs here and on the following pages, you can see the approach of Linda Sole through the images she produced while spending a few days at a ballet school local to her home in south London, England.

Linda's first contact was with the principal of the school. Over the years Linda has been working as a photographer, she has built up a large portfolio of children's portraits, and she took along to the meeting a wide selection of prints to give the principal some idea of her approach and the type of material she hoped to produce.

The school at that time was rehearsing for a ballet performance involving nearly all the pupils, from the very youngest to the more experienced students. In return for providing a complimentary set of prints for the school to use for publicity purposes, Linda was given free access during the rehearsals and a display area where parents could see her photographs and order prints of their children and their friends.

Photographic opportunities such as this can be commercially worthwhile simply as one-off ventures. However, once local parents are aware of you and your work there is always the chance that follow-up commissions may come your way.

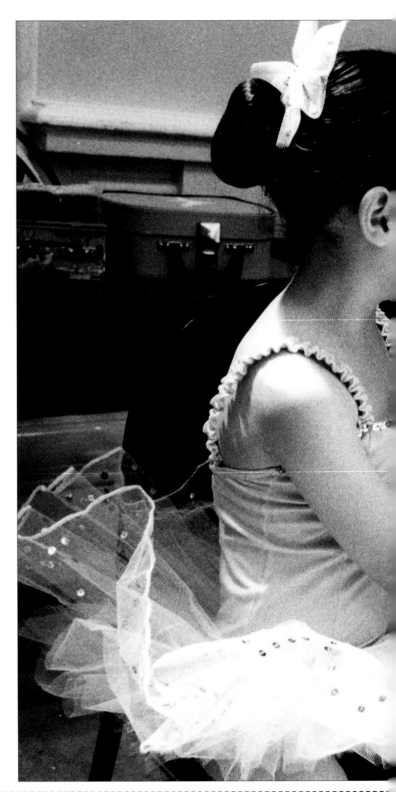

▶ Arriving early for her first session, Linda was set up and waiting before most of the young dancers had arrived for rehearsals. Initially, the girls were curious about this newcomer and she was the subject of many excited stares and whispered conversations. Working here in black and white, Linda did not have to worry about colour casts arising from a mixture of natural daylight from the windows and domestic tungsten room lighting that was available.

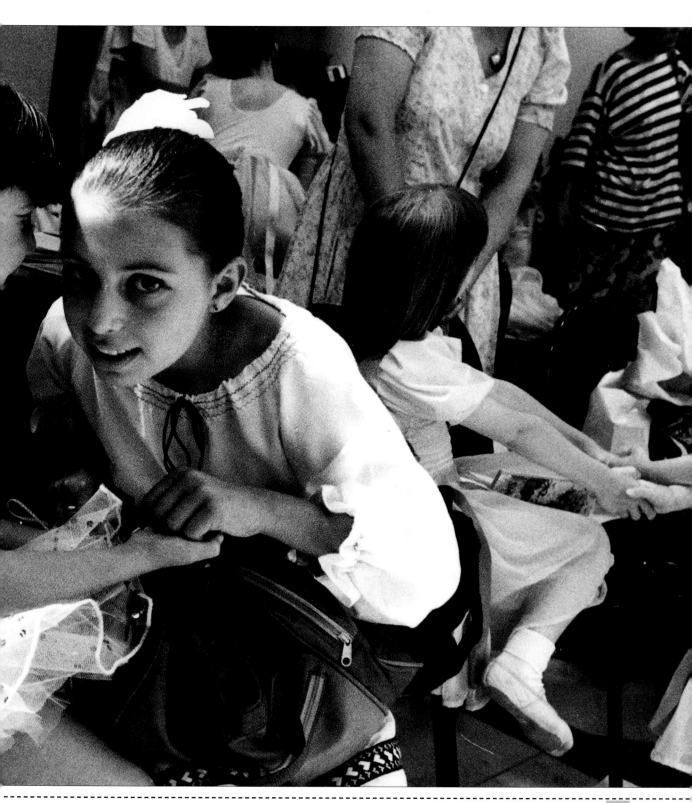

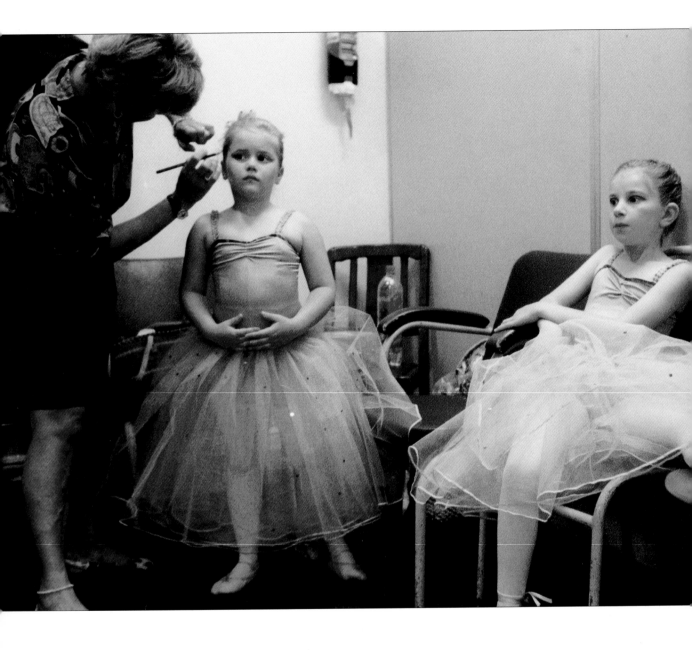

▲ ▶ *Sometimes the best approach to this informal, semi-candid type of photography is to find a likely location and then wait for the action to develop around you. To this quiet corner, the young dancers were coming in ones and two to have their make-up applied. After a relatively short time, the girls started to ignore the camera's presence and Linda was then able to record a series of unselfconscious facial expressions.*

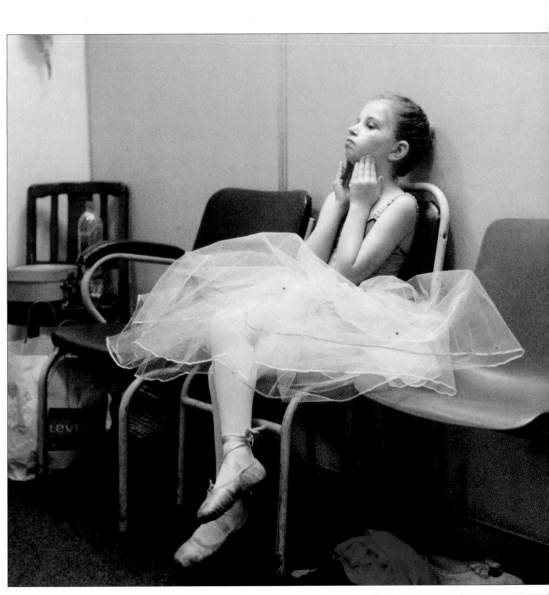

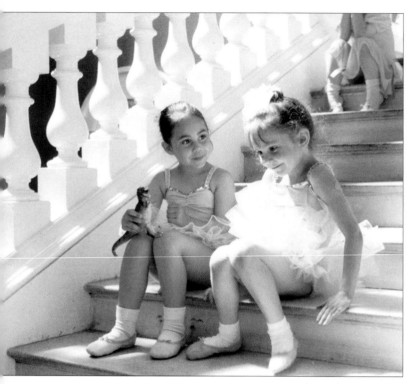

▲ When working outside of the studio, you are obviously very dependent on the ever-changing quality of the available daylight illuminating the scene. For this shot, Linda carefully took a light reading from the more shadowy features of the face of the girl on the left, using the spot-metering TTL (through the lens) facility offered by her camera. She knew that, as a result, the girl on the right would be slightly overexposed, but this has only helped to accentuate the delicate translucency of her lacy fronted tutu.

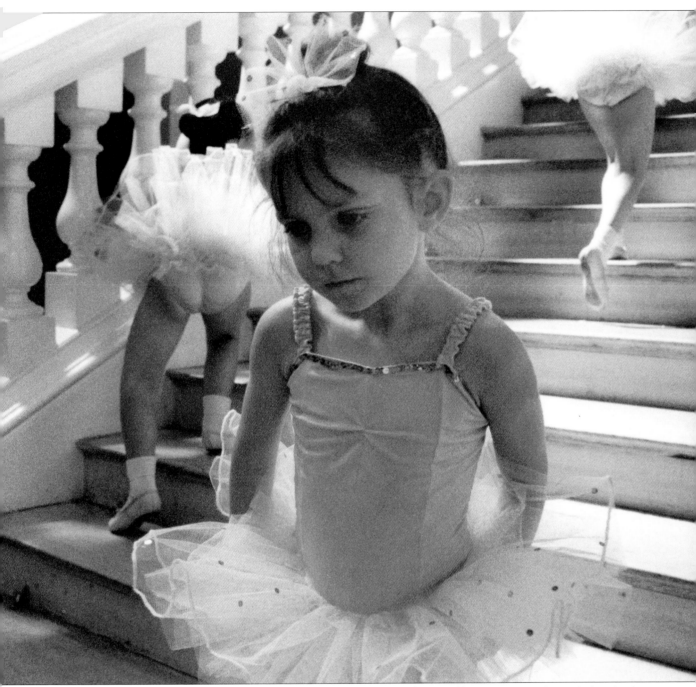

▲ When your subjects are highly mobile, it helps if you can respond quickly by adjusting the framing of your shots. The perfect lens for this is a zoom, which allows you to select from a wide range of subject framing without changing camera position. In this photograph, the main subject quite unexpectedly jumped up from the steps when she saw her friend approaching. Compensating for this, Linda zoomed back from a 70mm to a 35mm setting while managing to keep the subject well framed throughout.

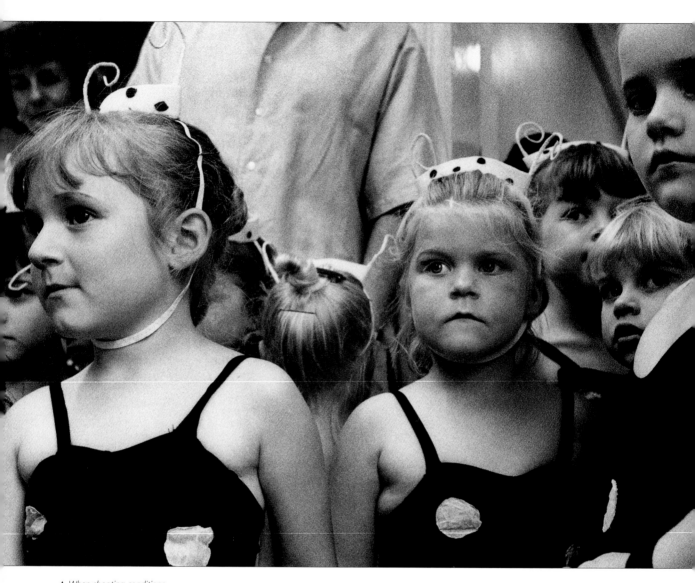

▲ *When shooting conditions are cramped and there is a lot of potentially distracting activity all around, you may need to get in close with the camera and shoot with a wide-angle lens. Good-quality optics will produce distortion-free results (unless the focal length is extreme), and the inherently wide depth of field associated with wide-angles makes focusing less of a critical factor.*

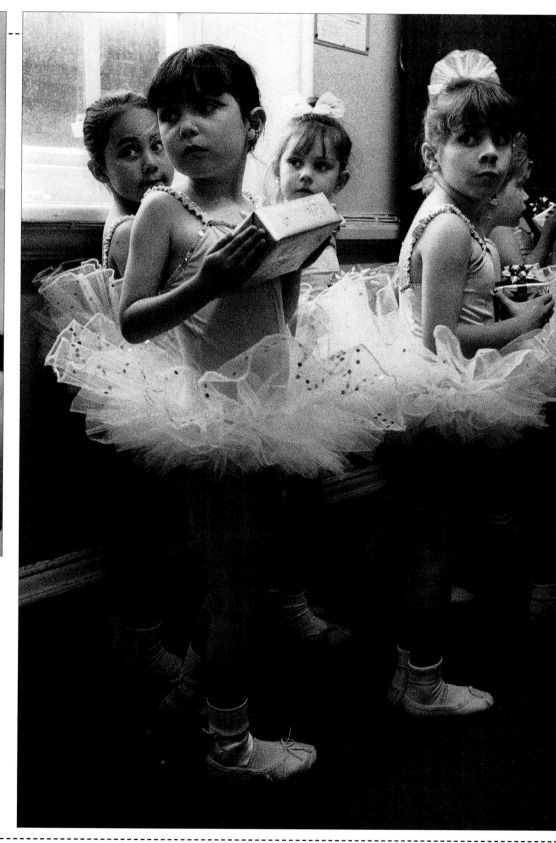

▶ Eyeline is important when photographing children. If you shoot from a normal adult standing height, the camera will be basically looking down on the tops of their heads, and your pictures will lose any feeling of intimacy. As you can see from this photograph, however, crouching down and shooting from either the height of the children's eyes, or slightly below it, helps the camera to enter their space and produces a more telling photograph as a result.

GEORGES-CHARLES VANRYK

The quality that most obviously characterizes the photographs of Georges-Charles Vanryk is that of 'naturalness' – naturalness in terms of lighting as well as the way in which his young subjects react both to his presence and to that of the camera. There is, however, no attempt to disguise the children's awareness of the recording process taking place. Indeed, despite their youth, they all seem to exhibit a sophistication and confidence far in advance of their years.

All the photographs reproduced in this portfolio come from a book entitled *Week-end*, which contains a series of photographs shot during the course of a single weekend in a small cottage on the coast of Belgium.

Born in 1933, Georges-Charles retains the ability to empathize with children, allowing the viewer to see through his work more than mere physical likeness by drawing from his subjects something of their character and temperament. His approach is essentially that of a candid photographer, however, taking on the role of dispassionate observer: 'I enjoy photographing children because I still feel very close to them. I encourage them to play on their own so that they organize their own activities and interactions. All I have to do is observe and record.' In terms of lighting, the daylight effect Georges-Charles has created in these pictures is a mixture of natural window light combined, when necessary, with large tungsten lighting units placed outside the cottage and shining in through the windows. In arranging these lights, it is important that both the artificial and natural illumination correspond in their lighting direction so that conflicting shadows are not created, something that would destroy the magic. Shooting in black and white as he does, there is no worry that the different colour temperatures of the light sources will produce any unnatural-looking effects.

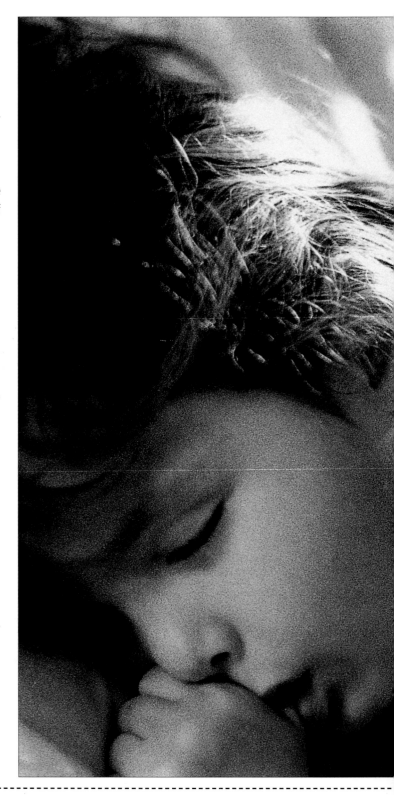

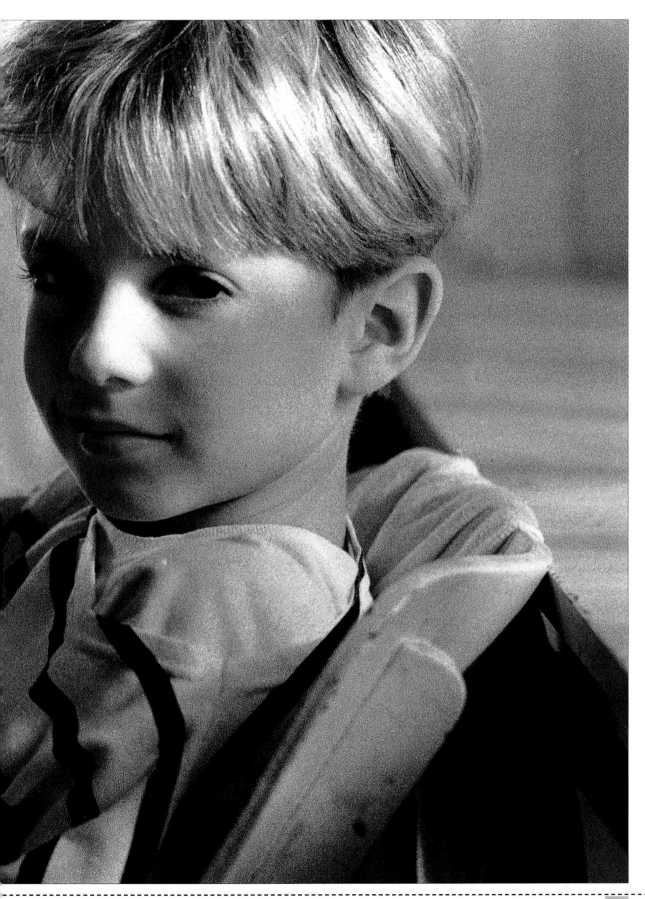

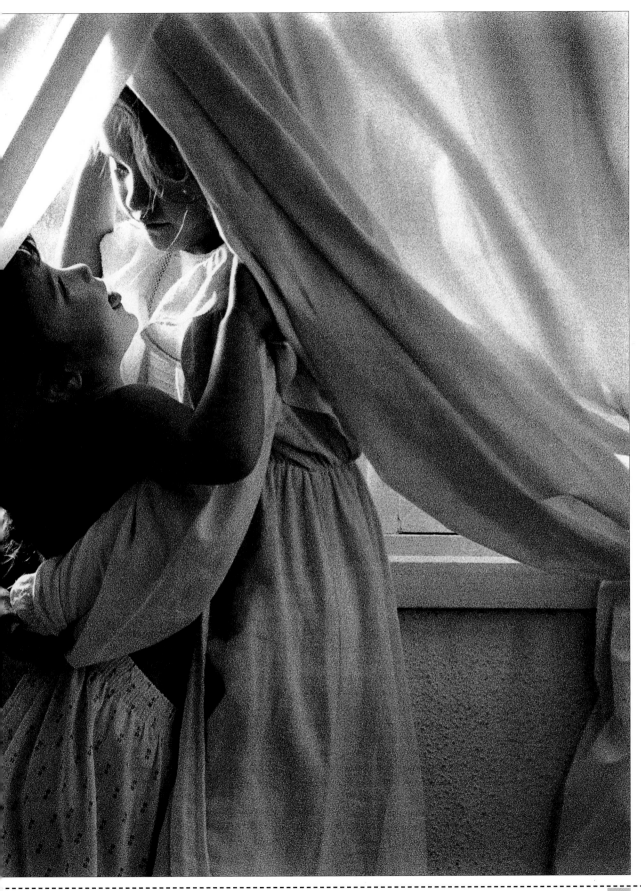

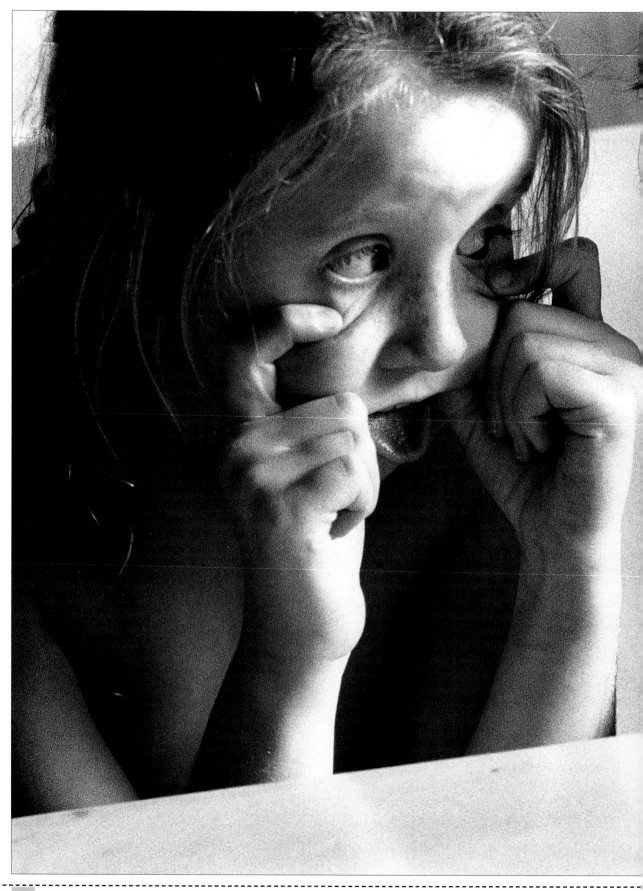

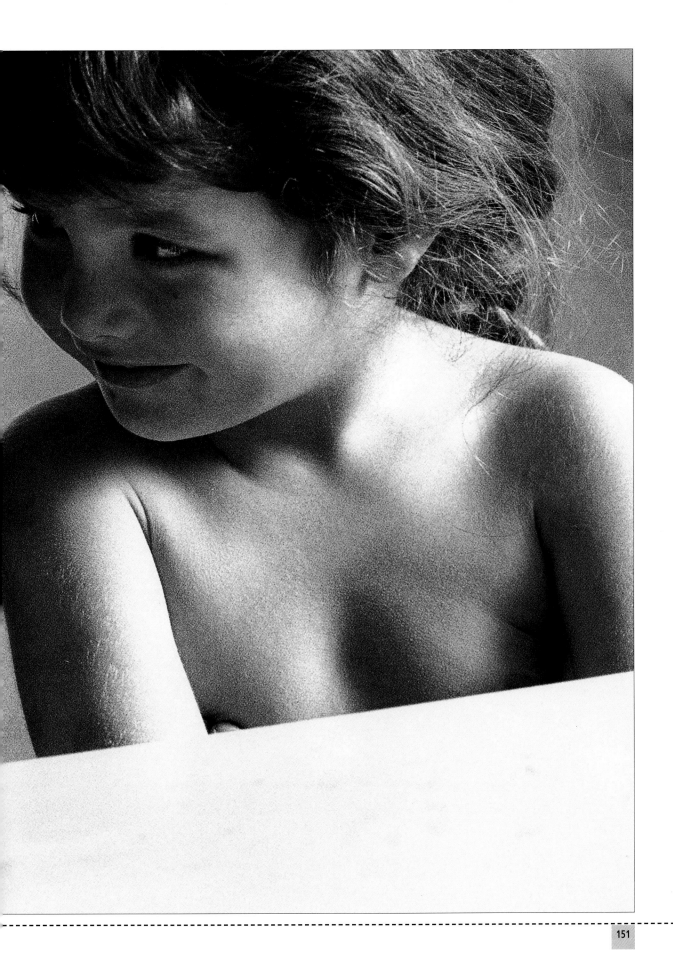

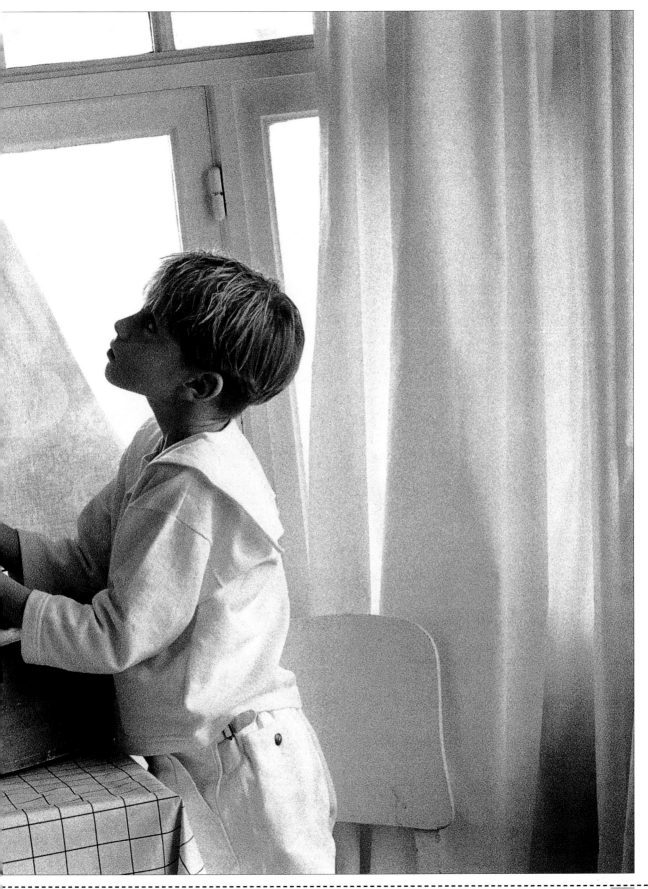

DIRECTORY OF PHOTOGRAPHERS

Robin Dance
12 Charlotte Street
Brighton BN2 1AG
UK
Telephone: + 44 (1273) 698329
Fax: + 44 (1273) 607711

Robin Dance was born in 1952. He trained at Colchester School of Art and Homsey College of Art, graduating in fine art in 1973. Robin has been a freelance photographer since 1986. As well as his interest in photographing children he also specializes in landscape work.

Photographs on pages 50, 70, 82, 83

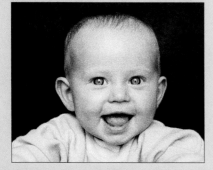

Desi Fontaine
60-62 Archway Street
Barnes
London SW13 0AR
UK
Telephone: + 44 (181) 8784348

Photographs on pages 38, 39, 53

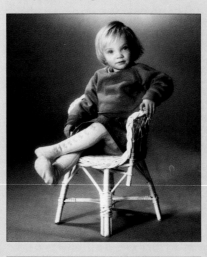

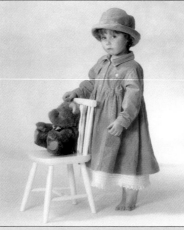

Juliet Greene
'Terracotta'
Britains Lane
Sevenoaks
Kent TN3 2NF
UK
Telephone & Fax: + 44 (1732) 743876
Mobile: + 44 (973) 227414
Email: JMGPhoto@aol.com

Juliet's interest in photography stretches back to when she was eight years old. Later, after completing three years of college training specializing in photography, she landed her first job as a photographer, shooting children's fashions.

Juliet's interest in working with children continues to this day, but she has also specialized in travel, garden, and still-life photography. She is a member of the Association of Photographers and occasionally writes for the Association's magazine, *Image*.

Photographs on pages 126, 127, 128, 129

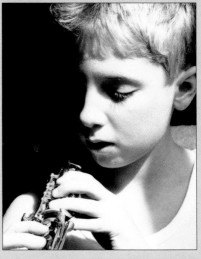

Nigel Harper ABIPP AMPA CrGWP
21 George Road
Stokenchurch
High Wycombe
Buckinghamshire HP14 3RN
UK
Telephone: + 44 (1494) 483434

In 1988, after pursuing several different careers without any real satisfaction, Nigel decided to take a chance and turn his long-standing hobby into a, hopefully, enjoyable profession. He enrolled in two of Fuji's one-day seminars on wedding and portrait photography, and these were enough both to inspire him and to demonstrate his natural abilities in these photographic fields. His photographic business and studio is now based at his home, where his wife takes care of the administrative details leaving Nigel to concentrate on the photography and printing. Although his photographic career is only short, it has been punctuated by many awards: 1981 and 1982 winner of the Kodak Bride and Portrait Awards; more than 40 separate Fuji photographic awards, including 15 quarterly wins in the last two and half years; 1994 Fuji Wedding Photographer of the Year; and the Hargreaves trophy for the winning wedding portfolio in 1994. As well as running his thriving photographic business, Nigel also finds time to lecture on wedding photography in the UK and abroad.

Photographs on pages 72, 73, 87, 88, 89, 112–3

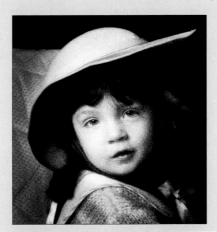

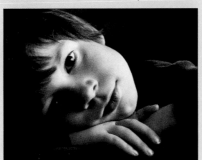

Alan Harriman
22 Vallance Road
London N22
UK
Telephone: + 44 (181) 8881009

Alan is an amateur photographer with a special interest in photographing children. He has photographed ice hockey teams for the last ten years.

Photographs on pages 68, 68–9

Majken Kruse LBIPP
The Coach House
East Compton
Shepton Mallet
Somerset BA4 4NR
UK
Telephone: + 44 (1749) 346901

Majken is a professional photographer with an active photographic practice specializing in weddings and portraiture. She started her working career in front of the camera as a model. At that time, photography was more of a hobby, albeit an important one. This experience, and a natural eye for photographic composition, led her to taking up photography professionally. Majken initially concentrated on children and general portraiture before widening her portfolio. She firmly believes that her experience in front of the camera helps her to relate to, and work effectively with, her subjects to achieve a natural look. Her creative talent, together with years of experience, are reflected in a very individual style.

Photographs on pages 26–7, 28, 42, 56–7, 96, 97, 116, 123, 124–5, 130, 130–1

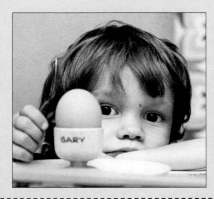

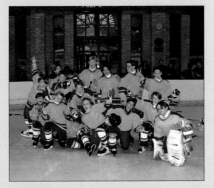

Anne Kumps
Leuvensebaan 334
3040 St Agatha Rode
Belgium
Telephone & Fax: + 32 16472635

Anne Kumps has been a freelance photographer since 1983. Although at ease with a wide range of commissions, Anne has a particular interest in portraiture and photographing children. She puts her success down to two guiding principles: an open approach to her subjects and a huge amount of patience.

Photographs on pages 1, 18, 19, 20, 21, 42, 43, 45, 60, 61, 84, 85

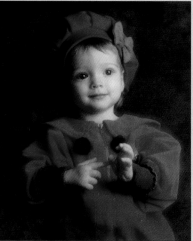

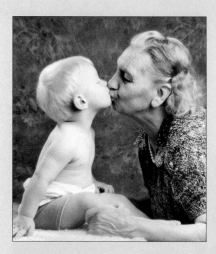

Peter Millard
5A Scampston Mews
London W10 6HX
UK
Telephone: + 44 (181) 9681377
Fax: + 44 (181) 9680104
Mobile: + 44 (831) 465240
Email: peterm@slingshot.co.uk

Born in 1960, Peter Millard attended art college for a two-year foundation course in art and design after finishing high school. In 1977, Peter was placed second in the prestigious national competition Young Photographer of the Year. This was followed by three years at Harrow College of Higher Education, where he obtained a degree in applied photography, film and television, specializing in advertising and editorial photography. On leaving college, Peter immediately embarked on a freelance career, working initially as a photographic assistant. After a brief involvement in audiovisual and video production, he returned to mainstream photography in 1985. After another three years as an assistant, Peter established his own business. Most of his work is now studio based, and is broadly split between still-life product and set photography for the advertising industry, and photographing children involved in activities and projects to illustrate books for use in education. Since working for children's book publishers in the late 1980s, Peter's pictures have been used to illustrate more than 80 individual titles, and these have been published throughout the English-speaking world as well as in France, Germany, Holland, and Sweden.

Photographs on pages 46–7, 51, 52, 74, 75, 76, 77, 98

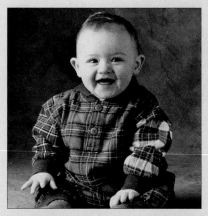

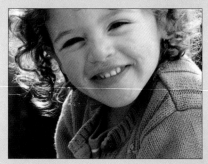

Tim Ridley
Wells Street Studios
70–71 Wells Street
London W1P 3RD
UK
Telephone: + 44 (171) 5805198
Fax: + 44 (171) 3233690

Tim Ridley is an established freelance photographer, having started in the business more than 15 years ago as a photographic assistant. In his West End studio in central London, Tim specializes in publishing, public relations, and design

group clients. Recently, a series of Tim's photographs won a place in the annual Association of Photographers competition. His favourite medium is black and white and he particularly enjoys working with both children and animals.

Photographs on pages 22, 23, 24, 25, 95, 107, 108–9, 109, 110, 111, 112

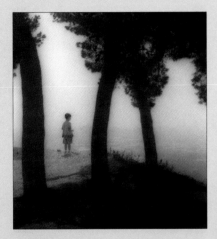

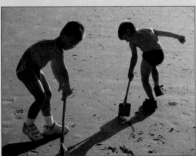

Llewellyn Robins FBIPP FRPS

Llewellyn Robins Studio
64 Enborne Road
Newbury
Berks RG14 6AH
UK
Telephone: + 44 (1635) 42777
Fax: + 44 (1635) 522768
Email: http://www.llrs.demon.co.uk

Robin Llewellyn has been photographing people professionally for about 30 years. He is probably best known for his more candid work – photographing children at play in gardens, the countryside, or other outdoor locations. His preference is for a relaxed approach to photographing young people. Believing that better pictures result if you know your subjects, Robin always takes the time to gain their confidence before thinking about picking up his camera. Robin has a fellowship in photography from both the British Institute of Professional Photography and The Royal Photographic Society. He has also lectured on his individual style and approach to photography in the UK and the United States.

Photographs on pages 30–1, 31, 32–3, 40, 44, 63, 64–5, 66, 67, 81, 102, 103, 114, 115, 118, 119

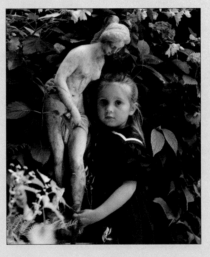

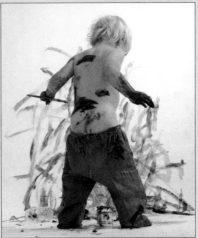

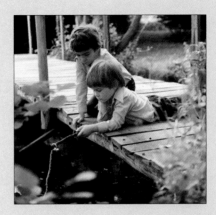

Nicholas Sinclair

c/o Jo Clark
13 Prowse Place
London NW1 9PN
UK
Telephone: + 44 (171) 2677267
Fax: + 44 (171) 2677495

Although born in London, Nicholas Sinclair studied fine art at the University of Newcastle-upon-Tyne between 1973 and 1976. Since leaving university, his photographic work has been widely exhibited and published in Britain, mainland Europe, and in the United States of America. Nicholas's work is now represented in the permanent collection of the National Portrait Gallery, London.

Photograph on page 55

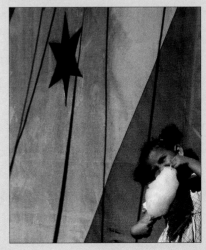

Linda Sole

33 Coleraine Road
London SE3 7PF
UK
Telephone: + 44 (181) 8588954
Fax: + 44 (171) 7398840

Born in 1943 in Ireland's County Durham, Linda Sole now lives and works in southeast London earning her living as a freelance photographer concentrating principally on reportage and photo-documentary. Linda joined the Independent Photographers' Project in 1983, organizing workshops and photographing local events. Teaching photography has been a strand running through Linda's career, and she has taught and lectured on photography at various schools and colleges in Britain and abroad. She was also resident photographer at Blackheath Concert Halls between 1991 and 1993, where she held two exhibitions of her work. She also taught photography in France while working for a theme holiday company. As well as exhibiting regularly at Hays Gallery in Deptford, London, Linda is also the winner of numerous photographic competition awards.

Photographs on pages 29, 48, 49, 58–9, 71, 94, 99, 100–1, 116–7, 134–5, 136–7, 137, 138, 138–9, 140–1, 141

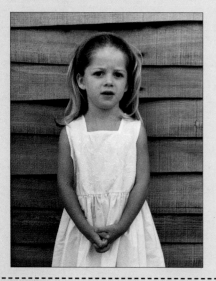

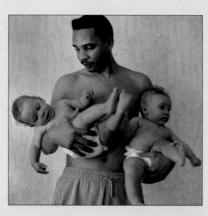

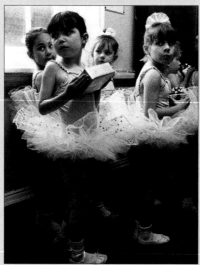

Jos Sprangers FBIPP

Dorpstraat 74–76
4851 CN Ulvenhout
The Netherlands
Telephone: + 31 (76) 613207
Fax: + 31 (76) 601844

As well as being a Fellow of the British Institute of Professional Photography, Jos is also a qualified member of the Dutch Institute of Professional Photography. In 1970 Jos started his own business, combining photographic retailing with general photographic work. By 1980, however, he abandoned the retailing side completely to concentrate solely on undertaking commissioned photography. He is a three-time winner of the Camera d'Or. Throughout the years Jos has won many prestigious competitions, culminating in being judged Brides Photographer of the Year (England) in both 1992 and 1993. As well as running his business as a professional photographer, Jos has also been invited to lecture not only in his native Holland, but also in Belgium, Germany, England, Scotland, Norway, and Cyprus.

Photographs on pages 41, 54, 125

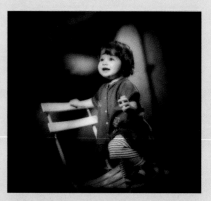

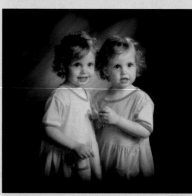

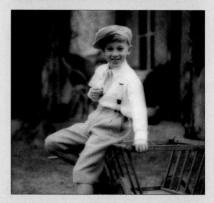

Ronald Turner
336 North Road
Cardiff CF4 3BP
Wales
UK
Telephone: + 44 (1222) 626131
Fax: + 44 (1222) 520942

Ronald Turner works as part of a team with his photographer daughter, Tracy, and wife, Barbara, who looks after the backroom aspects that are so important to a successful business. Their studio, based in Cardiff, Wales, has notched up an impressive number of awards – 25 Kodak Gold Awards plus many others, including Kodak Portrait Photographer of the Year 1997 and International Wedding Photographer of the Year. Ronald and Tracy are Fellows of the British Institute of Professional Photography and winners of numerous BIPP awards.

The Turners' main speciality is location portraiture. Ronald Turner explains that while camera technique is important, it is what happens in front of the camera that determines the success of a portrait. This includes a good knowledge of how to exploit the many moods of natural light, people skills, the use of body language, and how to pose your subjects and elicit good facial expressions. He maintains that portraiture is one part technique and nine parts psychology – although sometimes it turns out to be one part technique and nine parts moving furniture.

As well as having their photographs exhibited on a number of occasions at Walt Disney World, Florida and at the Photography Hall of Fame & Museum, Oklahoma City, the Turners also regularly hold master classes and seminars on a worldwide basis. Venues so far have included the USA (eight times), Continental Europe, Scandinavia and many engagements in Britain and the Republic of Ireland.

Photographs on pages 2–3, 7, 8, 34, 35, 36, 37, 80, 90, 91, 92, 93

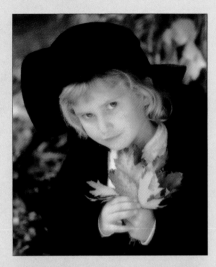

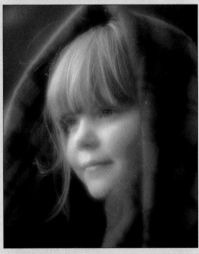

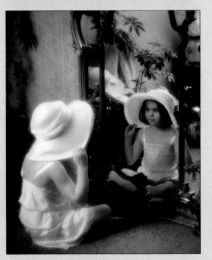

Georges-Charles Vanryk
Albertlaan 81
B-8300 Knokke
Belgium
Telephone & Fax: + 32 50625680

Born in 1933, Georges-Charles Vanryk has been an interior designer for more than 25 years. As well as this career he is also an established fashion and advertising photographer in his native Belgium with a growing worldwide reputation. Whenever time permits in his busy schedule, he still finds time to photograph one of his favourite subjects – children. His most recently published book, entitled *Week-End*, is a collection of prints taken over the course of a single weekend's shooting session with a group of children in a cottage on the Belgium coast. His work is often exhibited in Belgium, especially his portrait studies.

Photographs on pages 142–3, 144–5, 146–7, 148–9, 150–1, 152–3

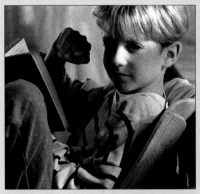

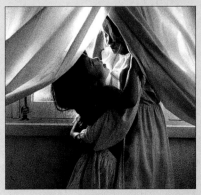

ACKNOWLEDGEMENTS

In large part, the production of this book was made possible only by the generosity of many of the photographers who permitted their work to be published free of charge, and the publishers would like to acknowledge their most valuable contribution. Similarly, the publishers would also like to thank all of the subjects who appear in the photographs included in this book.

The publishers would also like to thank the following individuals and organizations for their support and professional and technical assistance and services, in particular Brian Morris, Angie Patchell, and Natalia Price-Cabrera at RotoVision SA, E.T. Archive, and the equipment manufacturers whose cameras, lenses, flash units and other lighting equipment appear at the beginning of the book, and especially to the importers of Hasselblad and of Multiblitz.

All the illustrations in this book were drawn by Julian Bingley.

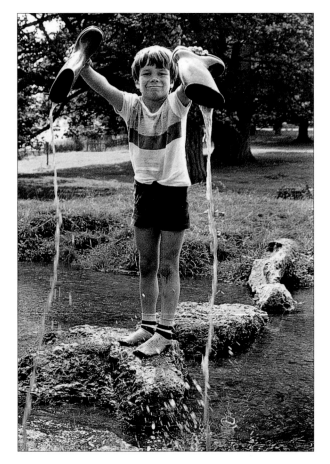